IMAGES
of America

SPENCER

IMAGES
of America

SPENCER

Spencer Historical Society

ARCADIA

First printed in 2002.

Published by Arcadia Publishing,
an imprint of Tempus Publishing Inc.
2A Cumberland Street
Charleston, SC 29401

Printed in Great Britain.

Library of Congress Catalog Card Number: 2002108573

For all general information contact Arcadia Publishing at:
Telephone 843-853-2070
Fax 843-853-0044
E-Mail sales@arcadiapublishing.com

For customer service and orders:
Toll-Free 1-888-313-2665

Visit us on the internet at http://www.arcadiapublishing.com

On the cover: An interior view shows Spencer's first five-and-dime store, located at the corner of Wall and Mechanic Streets. Joe Mack, proprietor, and Eva Gregoire, clerk, are seen in this *c.* 1910 photograph.

CONTENTS

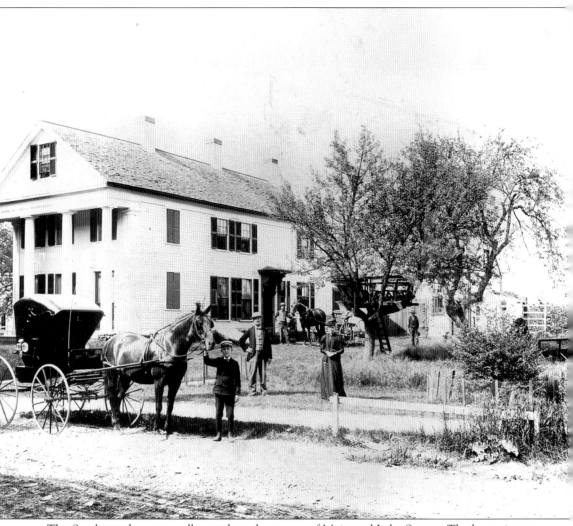

The Sanderson home proudly stands at the corner of Main and Lake Streets. The home is now recognized as the dental offices of Dr. Kevin Grace.

INTRODUCTION

Spencer's early years were spent as a typical New England town, compiled mostly of family farms supplying their own needs and running small enterprises to gain income. After the American Revolution, things slowly changed as early industries quickly grew into larger businesses, such as boot and shoe, wire, woolen, and gunpowder mills. This caused a need for additional workers, which brought in considerable numbers of French Canadian and Irish immigrants. By the late 1800s, Spencer was a thriving town.

In the first part of the 1900s, these early industries were going out of business or moving due to changing economic reasons. By the end of World War II, a majority of their employees were working in factories in Worcester. The small farms were giving way to several large farms, such as Sibley Farm and Alta Crest Farm. Many small stores and shops held their own or were replaced by new owners.

Spencer today stands with one large industry, Flexcon, and many small businesses and a healthy economic outlook. It has grown in several ways since Samuel Bemis built the first permanent home on the banks of the Seven Mile River and near the early path to Brookfield. Spencer has changed immensely since those days, but it still has the vigor of its early settlers.

These photographs help to show how things were in those bygone years, some long before our time, some in living memory. We have tried to give as full a picture as possible of Spencer, showing the pleasure and the hardship in the time of our forbearers. This collection of more than 200 photographs traces the rich and diverse history of the town. Many important people in their day are included, as well as hardworking men and women, and townspeople having fun and participating in parades, graduations, and sporting activities. We created a tribute to these people through the help of many unknown photographers who did so much to preserve views of how our forbearers lived. It is our desire that this history appeals to everybody interested in local history, as well as to those who just would like to enjoy a nostalgic trip down memory lane.

We hope this pictorial history will interest and enlighten the reader. Perhaps some of us will see people and places we know, and that will bring back memories of these exciting times.

Finally we want to thank all the wonderful people who have lent their cherished photographs or have helped with their time and advice.

One
AGRICULTURE

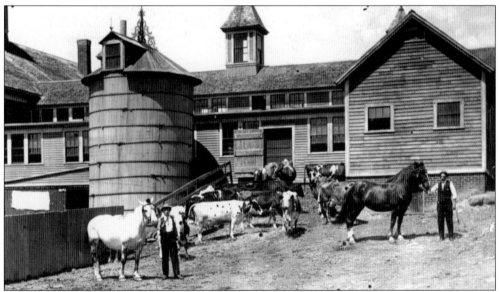

Alta Crest Farm, located at 85 Pleasant Street, was formerly known as the Village Farm. With its beginning in 1898 by Noah Sagendorph, the farm quickly grew and land was added behind Pleasant Street School. Whether a barn, wall, or house, the use of brick and stone in the construction was a trademark of the Sagendorph construction. The farm expanded to include land now occupied by St. Joseph Abbey.

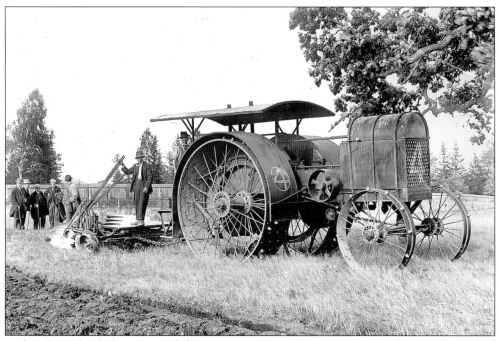

Arthur Sagendorph demonstrated the Big 4 traction machine in 1913. The behemoth weighed an impressive seven tons and was capable of drawing seven plows.

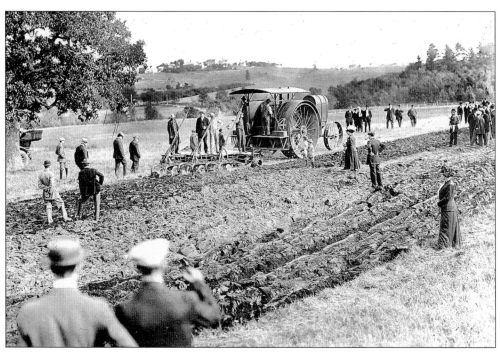

People came from surrounding towns to witness the tractor at work. Although they were fairly common on the western farms, the sight of one in Spencer drew much attention.

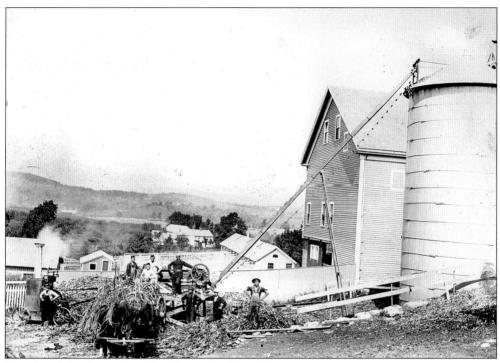

Farm hands load corn into the silo at Alta Crest Farm.

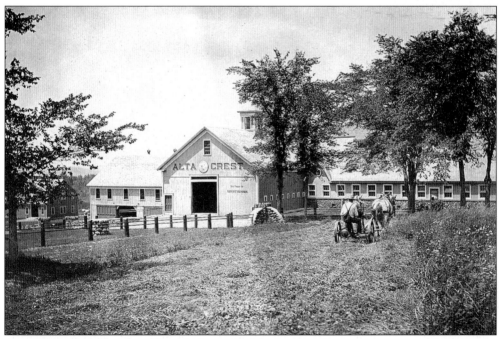

An early view of Alta Crest Farm is shown in this photograph.

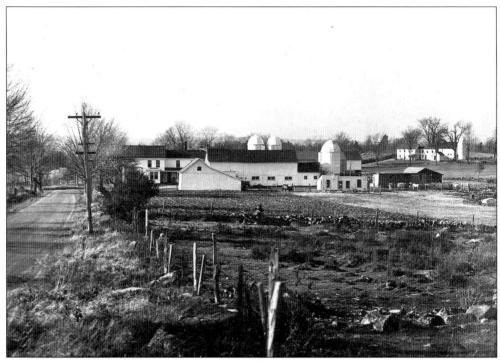

The Dwight Proctor farm on Northwest Road is shown before 1948.

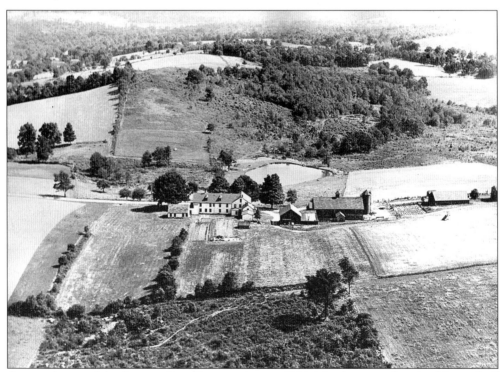

An aerial view of the Spencer Poor Farm is taken in 1924. The farm stood on land located off of Alta Crest Road that is now owned by St. Joseph Abbey.

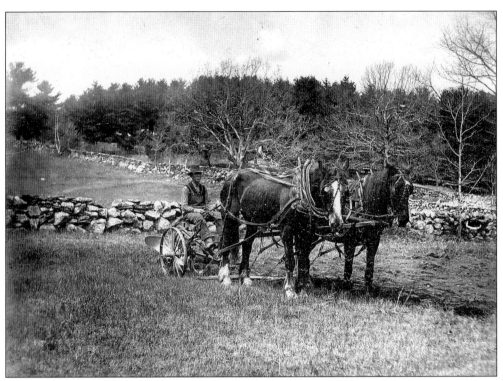

Charlie Rich plows a field at the Herbert H. Green farm on East Main Street.

A typical early farm scene, this is the Joshua Lamb farm. Built in 1741, it was the only gambrel-roofed home in Spencer. Destroyed by fire in 1940, it is now the site of the Pilling Farm on Kingsbury Road.

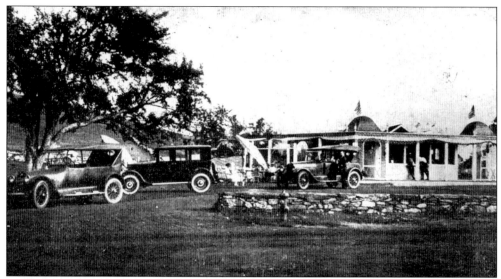

Sibley Farms Dairy Bar was located in front of what is now David Prouty Regional High School on East Main St. The building has been converted to a private residence and is still occupied.

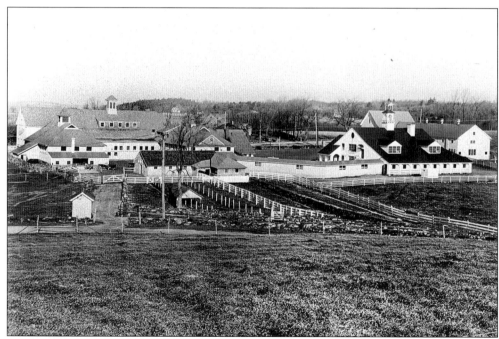

Sibley Farms, located where the regional high school now stands, is shown in 1940. Taken from the hill behind the farm, buildings now belonging to Ragsdale Chevrolet can be seen on the right.

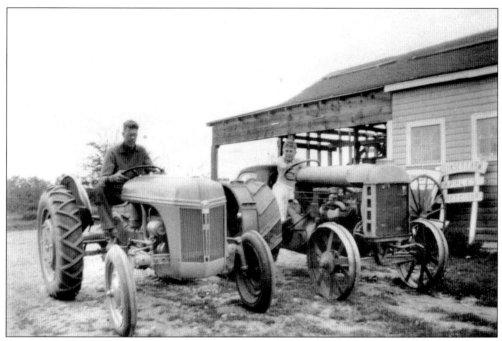

Warren and Richard Bemis compare tractors *c.* 1937. Note the rubber tires on the new tractor compared to the steel ones on the older machine.

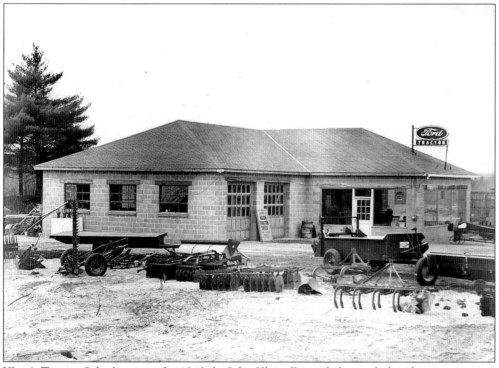

Klem's Tractor Sales began in the 1940s by John Klem. Expanded to include a department store at its West Main Street location, it is now run by Mike Klem.

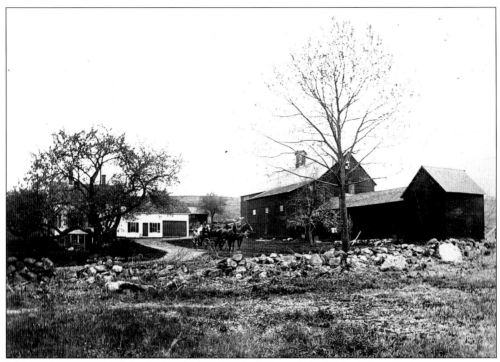

The Francis Bercume farm in South Spencer is shown c. 1910.

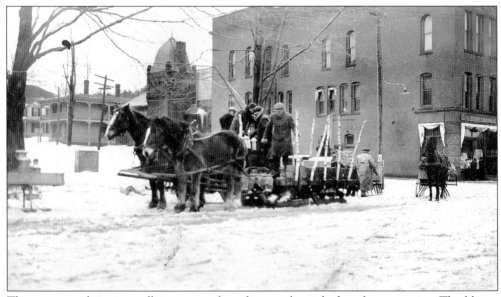

These men are bringing milk into town from farms to be picked up for processing. The library and Sugden Block are in the background.

Two

BUSINESS AND BUSINESS PEOPLE

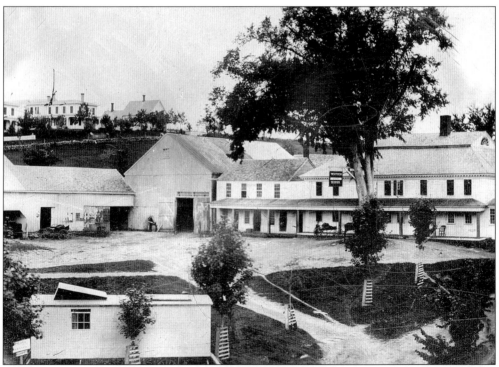

Jenks Tavern was destroyed by fire on September 20, 1870. The Hotel Massasoit was built and opened three years to the day later.

Girouard Bakery was located at the corner of Chestnut and Elm Streets. Pictured here are Amedee Cormier, baker, and David Girouard, owner.

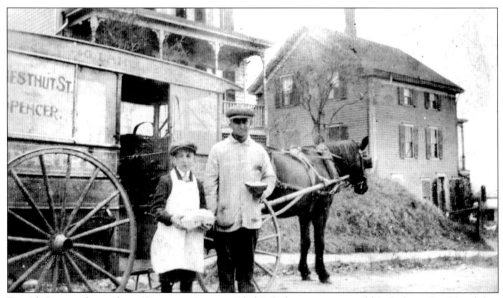

David Girouard stands on Prospect Street with his bakery wagon and his helper, Leo Vandale.

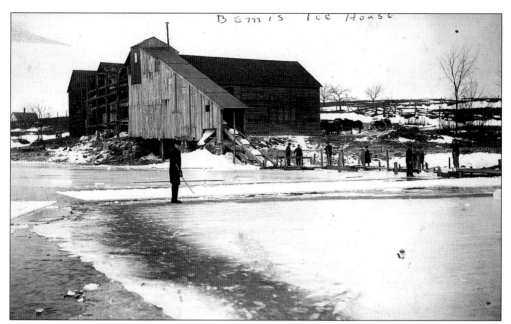

Ice was harvested on the north shore of Lake Whittemore by L.D. Bemis during the winter months and stored in the large buildings shown here.

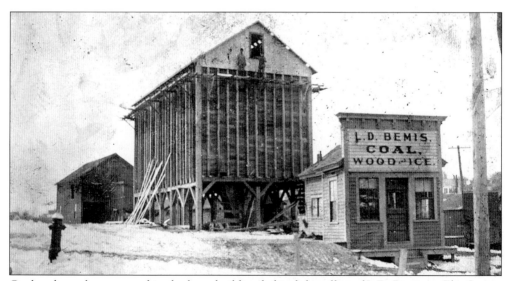

Coal and wood were stored in the large building behind the office of L.D. Bemis on Elm Street. Notice the two men near the open door at the top of the storage building.

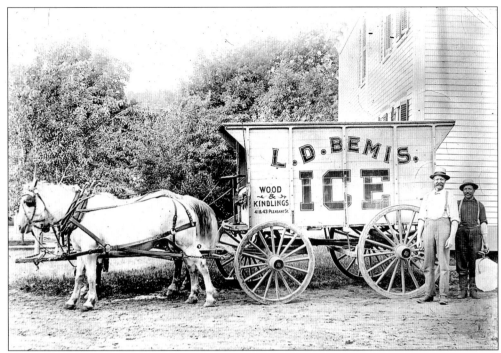

The delivery of the ice was done by wagon. Pictured here are L.D. Bemis and Pierre Cournoyer. Bill Fritze was the last man to deliver ice regularly in Spencer.

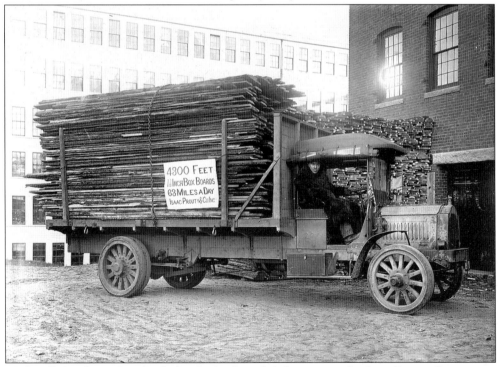

With Bill Combs at the wheel, this Packard truck belonging to the Isaac Prouty Company is loaded with shoebox boards.

Leo Ethier and Henry Cassavant sit on the front bumper of the Isaac Prouty Company's 1926 Pierce Arrow truck.

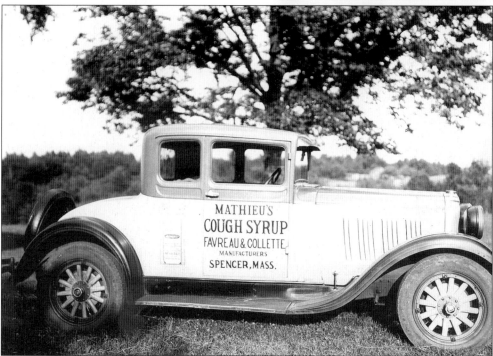

Edmund Collette's four-cylinder Dodge advertises Mathieu's famous cough syrup.

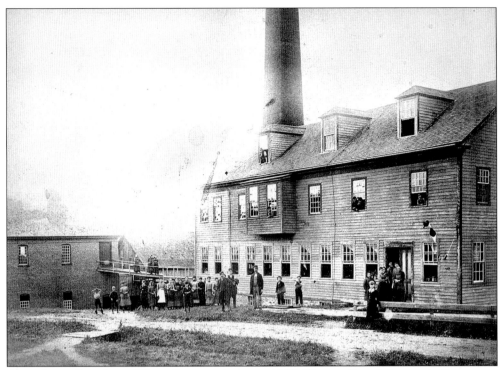

A woolen mill on lower Water Street is shown *c.* 1885. The smaller of the two buildings was later used as a cider mill and then a slaughterhouse.

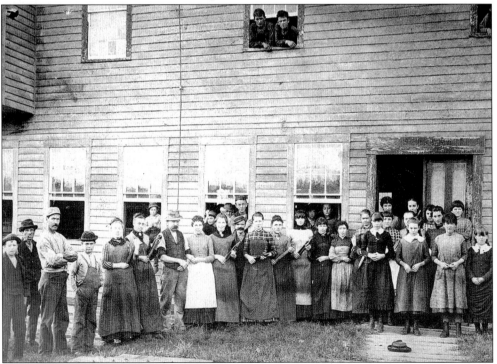

The varying ages of these woolen mill workers are representative of the work force in 1885.

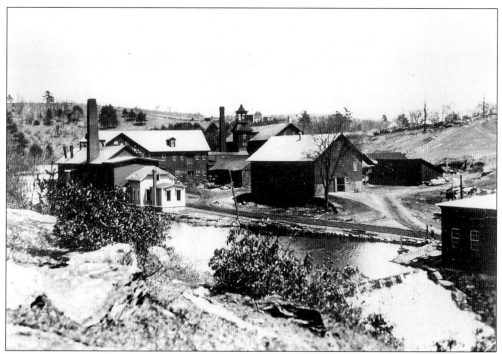

This photograph shows the upper Wire Village wire factory complex of the Spencer Wire Company.

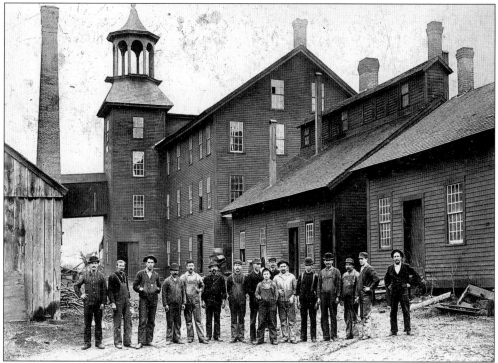

Workers line up to have their photograph taken in front of the Spencer Wire Company wire mill in upper Wire Village.

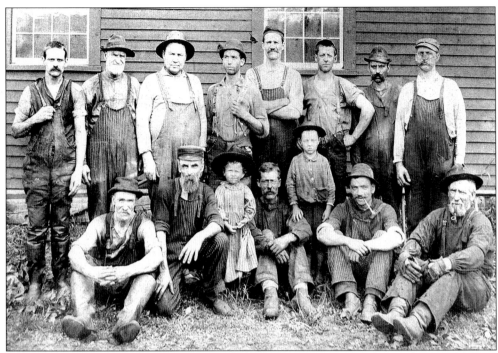

Seen here is an average group of friendly wire mill workers and two of their children. The age range seems to be from about four to sixty plus in this photograph.

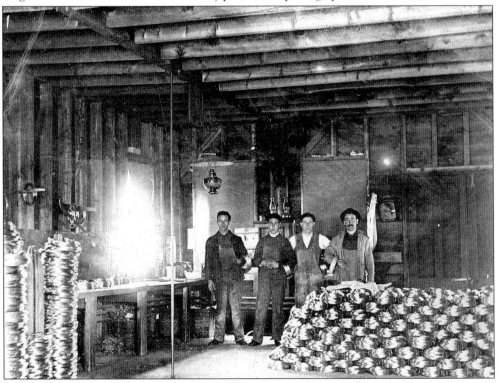

Wire mill workers pose behind spools of wire inside one of the many wire mills in town.

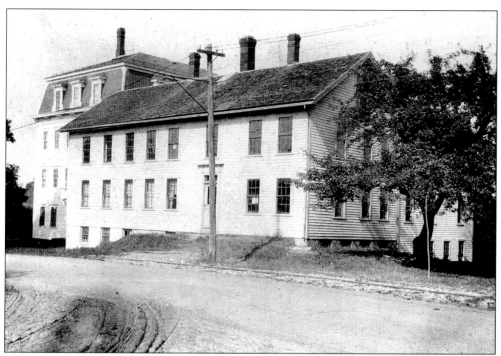

The Josiah Green Boot Company stood on East Main Street. The building is still in use as an apartment house and is located opposite the end of Greenville Street.

The new shop of the Josiah Green Boot Company was built in 1874, torn down, and rebuilt as the broom shop on Cherry Street in 1906. It is still standing and in use today.

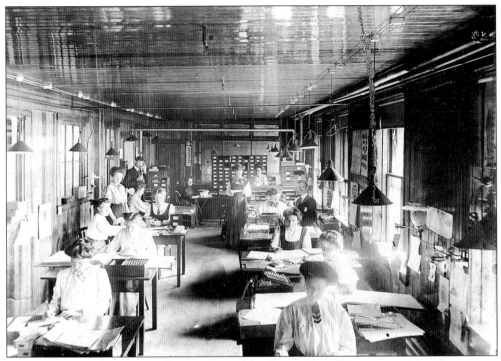

A 1911 photograph captures office workers of the Prouty Shoe Company on Main Street.

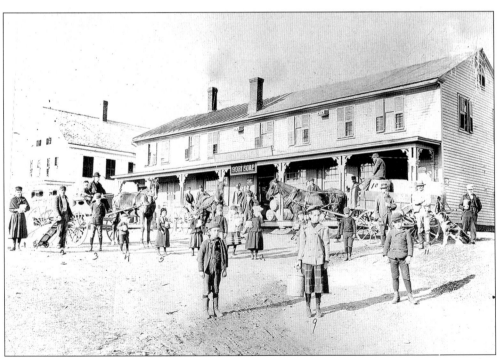

At the southwest corner of North Brookfield Road, one could browse the aisles of Chet Sylvester's store.

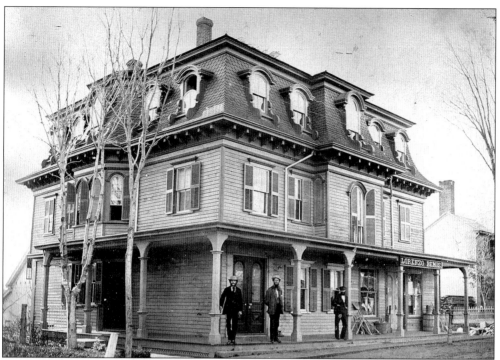

The Lorenzo Bemis store was located on the southeast corner of Elm and Main Streets. Destroyed by fire on January 1, 1880, it is now the site of a garage and auto body shop.

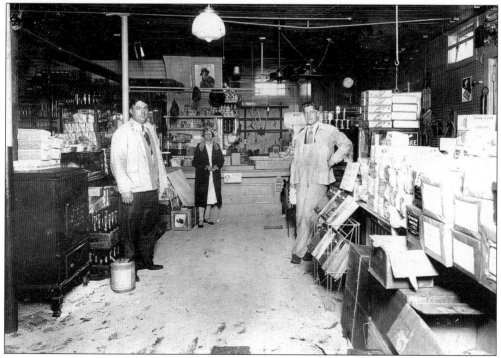

Lacroix's Market was located at 7 Chestnut Street in 1929. Pictured here are, from left to right, Clovis Perron, Delia Forrest, and Ed Lacroix.

The Town Broom Company building stands on Cherry Street. Originally, it was the Josiah Green Boot Company on East Main Street until it was torn down and rebuilt at its present site in 1906. The broom company ran its business at this location from 1931 until the late 1960s.

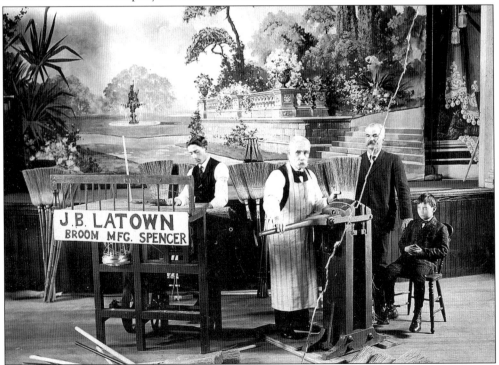

Large industrial shows were held in the town hall. Seen here is J.B. Latown's exhibit for his broom making business prior to 1925.

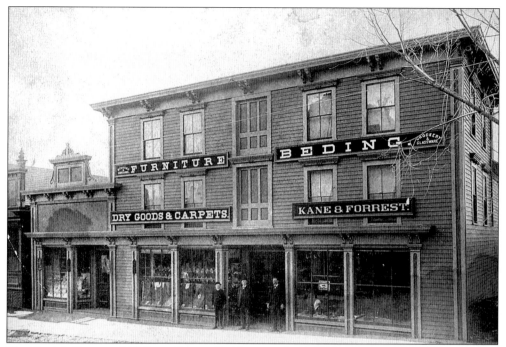

The Patrick Kane and William Forrest Building was built before 1873 at 38 Chestnut Street. Torn down in the 1920s, there is now a garage on its site.

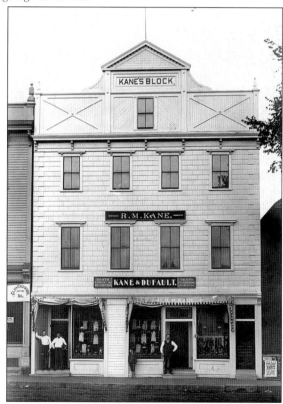

Richard Kane built the Kane Block in 1884. Located at 35 Mechanic Street, it once was used as the hall for the Order of Foresters. The building is still in use today.

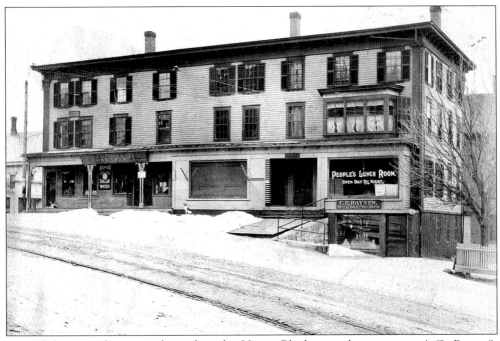

One of the many businesses housed in the Union Block over the years was A.G. Pease & Company Hardware.

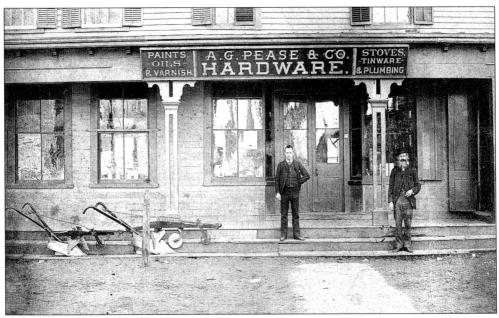

The Union Block was located at the southwest corner of Maple and Main Streets, where Cumberland Farms is currently located. It housed several businesses and apartments until it was destroyed by fire in 1964.

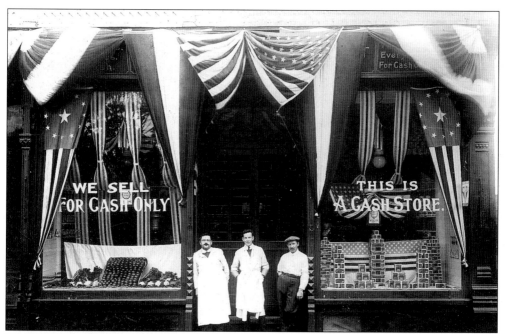

The Boston Branch Store, at the west corner of Main and Elm Streets, was owned by E.B. Honey and run by Frank Maher. Shown in this 1919 picture are, from left to right, Fred Arsenault, Frank Maher, and William Thibeault.

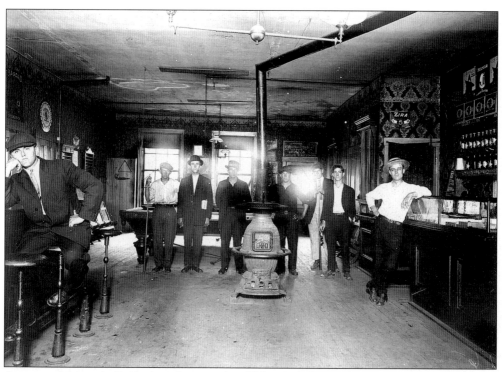

A group of thirsty individuals gathers inside of Ethier's Café on Chestnut Street *c.* 1915.

J. Elton Green stands next to the express wagon that was used in his market garden business.

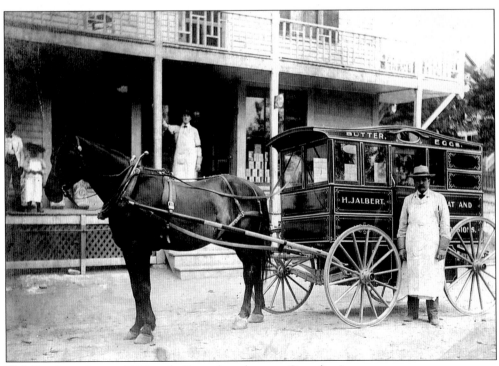

H. Jalbert's market on 17 Temple Street later became Graveline's.

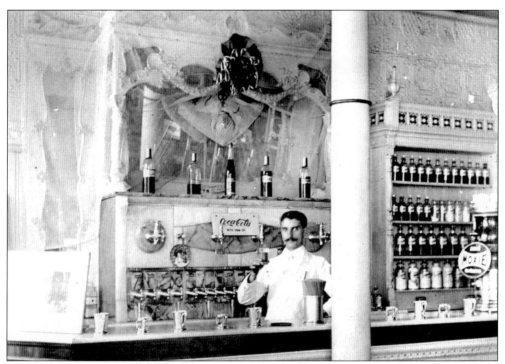

A 1903 photograph shows the soda fountain at Collette's drug store. Moxie was the drink of choice, but Coca-Cola was available for 5¢.

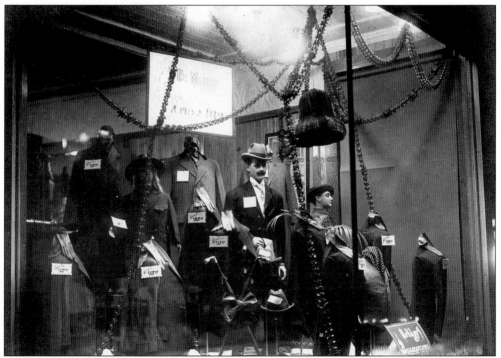

Collette's Clothing Store presents its Christmas window display. Prices on the lifelike mannequins run as high as $22.

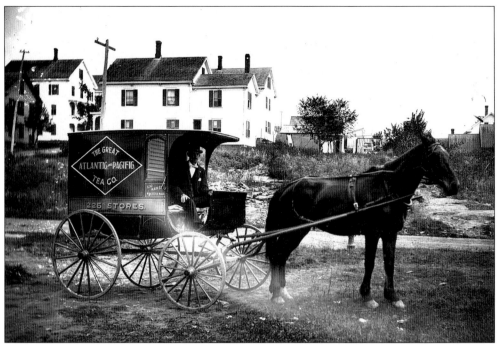

This photograph shows a delivery wagon of the Great Atlantic & Pacific Tea Company. The store stood at 20 Mechanic Street.

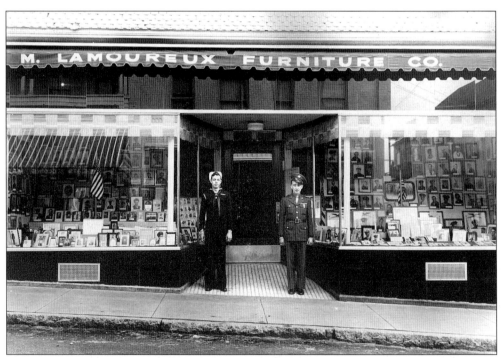

The M. Lamoureux Furniture Company on Mechanic Street displays servicemen and women in the store windows. Standing proudly in the doorway are Andrew O'Coin (left) for the U.S. Navy and Richard Guertin for the U.S. Army.

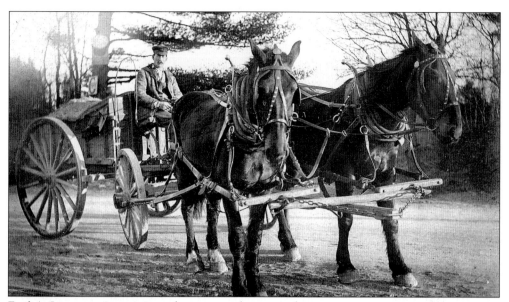

Fred A. Livermore's team is ready to move almost anything.

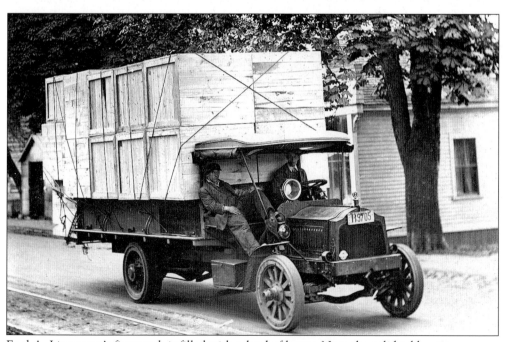

Fred A. Livermore's first truck is filled with a load of boxes. Note the solid rubber tires.

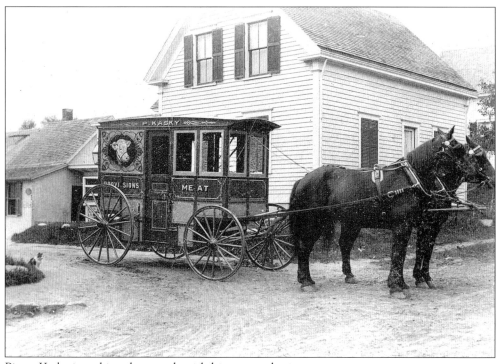

Pierre Kasky is making the rounds with his grocery business.

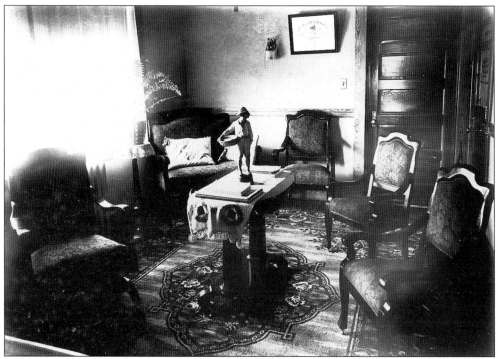

The waiting room in Dr. George H. Gerrish's office in the Sugden Block is shown in this 1920s photograph.

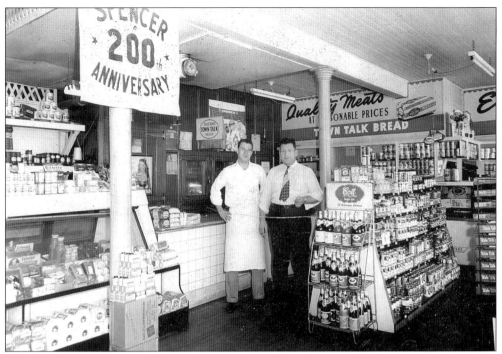

Hubert and Clovis Perron celebrate the town's 200th anniversary in the market on Chestnut Street.

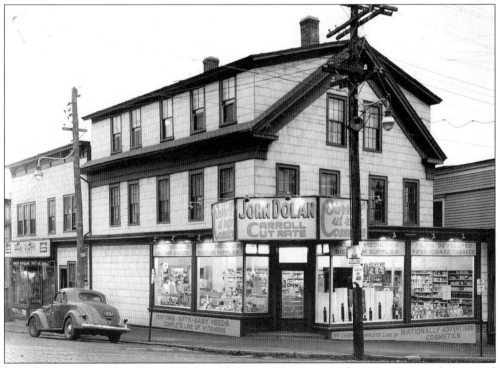

The pharmacy owned by John Dolan and his wife, Eleanor, stands at the corner of Main and Mechanic Streets.

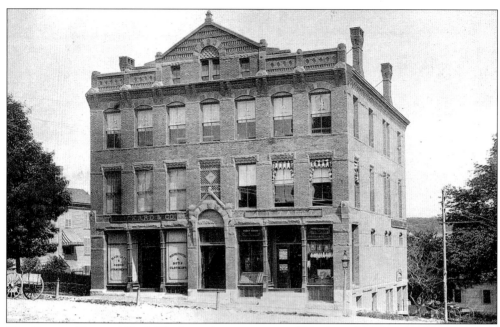

The Spencer National Bank Block, at the east corner of Maple and Main Streets, was built in 1876. Although no bank is using the building now, the Masonic Lodge uses the top floor for meetings, and the Worcester Telegram is in the storefront on the right.

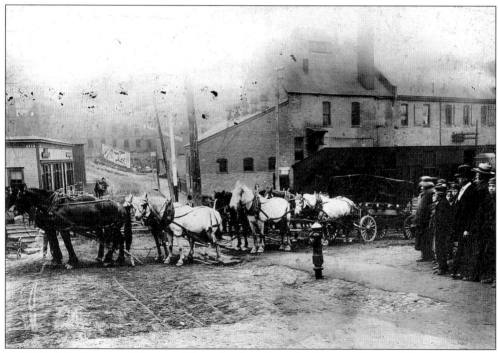

In 1910, eight horses pull the new 13-ton bank vault to the Spencer National Bank across from the town hall. In the background are Elm Street and the gas works.

Three

MUNICIPAL SERVICES
AND TRANSPORTATION

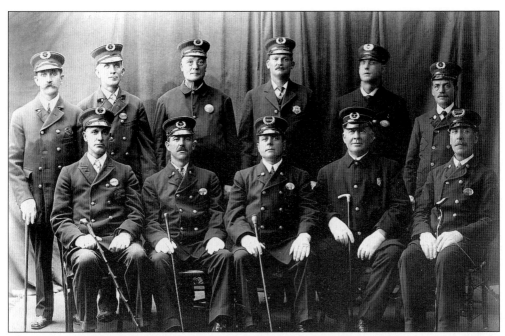

The Spencer Police Department members are shown *c.* 1920. Pictured here are, from left to right, the following: (front row) Harry Lyford, Joseph Laurence, Chief Louis Bazinet, John Norton, and Tennyson Bemis; (back row) Henry Lachambre, William Bosse, Joseph Collette, Joseph Lacroix, Napoleon Gaudette, and Julien Bouthelier.

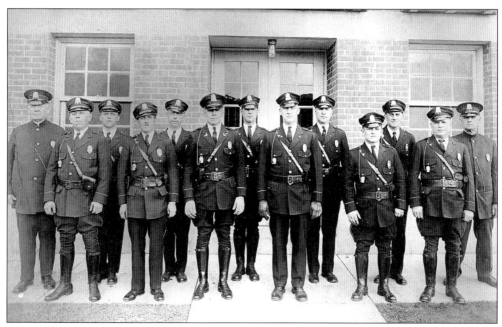

Members of the Spencer Police Department are seen in this 1930s view. Seen here are, from left to right, the following: (front row) Ed Lapierre, Leo Ethier, Chief Louis Grandmont, Charles H. "Dutchie" Meloche, Louis Letendre, and Peter LeDoux; (back row) Jack Norton, W. Fecteau, B. Bassett, T. LaCaire, Frank Bouvier, Mike Jette, and Napoleon Gaudette.

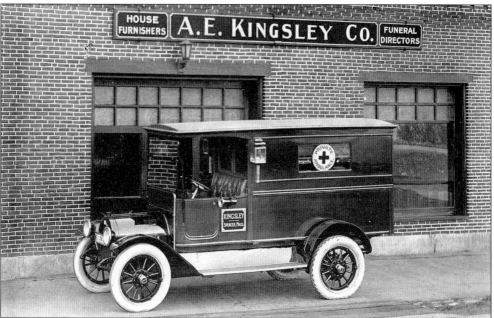

Arthur Kingsley brought the first ambulance to town in 1907. His son continued the service, and when the Kingsley Funeral Home was sold, the new owner, J. Alden Wentworth, continued providing service until 1956 when it was found unprofitable. After three years without ambulance service, a group of civic-minded citizens founded what is now known as the Spencer Rescue Service Inc.

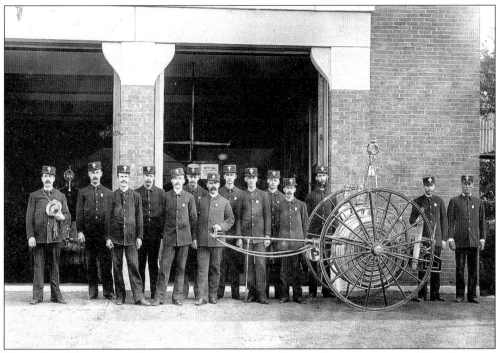

The John O'Gara Hose Company is shown at the Cherry Street station in 1884. The hose carriage was pulled by hand.

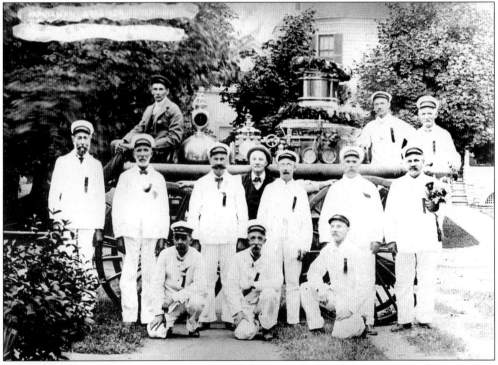

The 1871 Hunneman Steamer and some of the veteran fire department members pose on Muster Day, 1901.

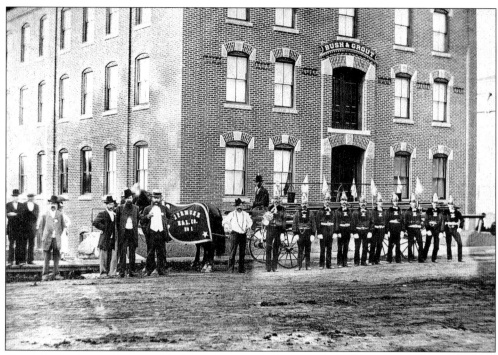

The John R. Grout Hook and Ladder Company No. 1 stands in front of the Bacon/Collette Block at 136 Main Street.

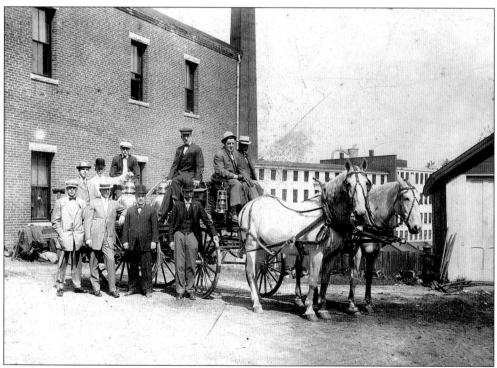

The Dexter Bullard Extinguisher Company put out many fires with its two chemical tanks. The picture was taken in 1911 on the east side of the Main Street firehouse.

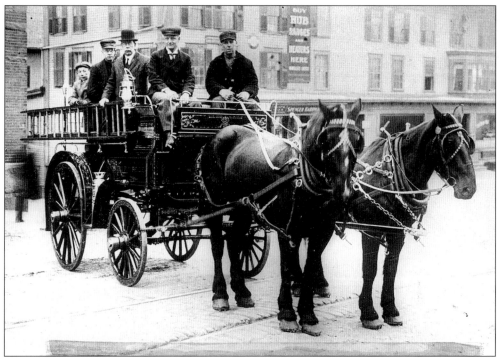

John R. Rogan (third from the left) and Charles Dunton (fourth from the left) are pictured here. Both men were fire chiefs during their careers. They are sitting on the 1912 two-horse hose wagon on the corner of Main and Maple Streets.

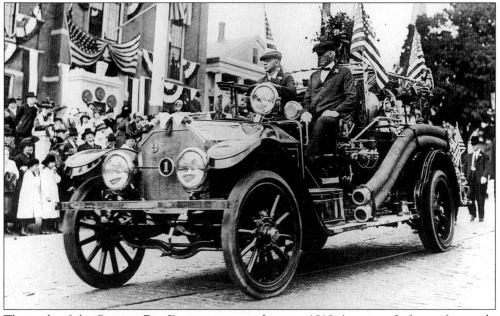

The pride of the Spencer Fire Department was this new 1919 American Lafrance fire truck, displayed during the World War I veteran's parade. Note the wooden spoke wheels and solid rubber tires. Chief Charles Dunton is on the right.

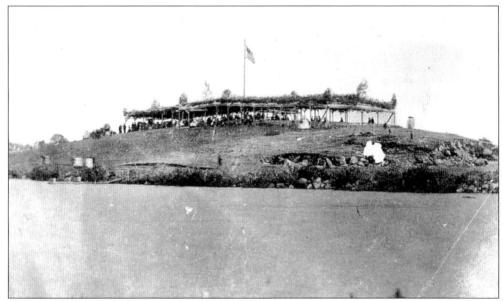

A huge celebration took place on August 14, 1884, at Shaw Pond when Spencer bought the water works. The giant wigwam seated 2,000 people. Approximately 5,000 showed up.

Fear of sabotage during World War I prompted the posting of armed guards at the pump house on Lake Whittemore.

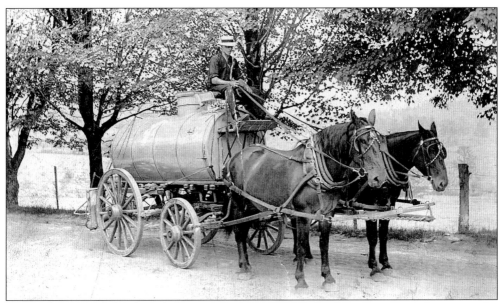

The horse-drawn street waterer was used to hold down the dust in residential areas in the early 1900s.

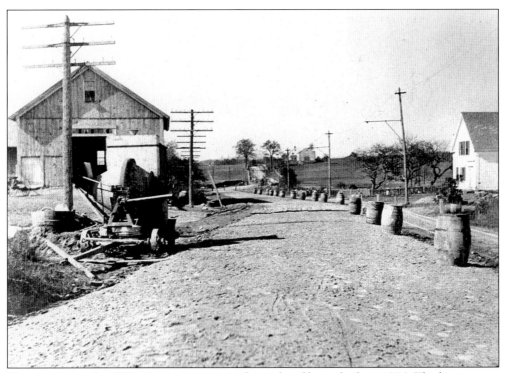

The cement road on West Main Street is in the midst of being built in 1906. The barn is now the site of Klem's store.

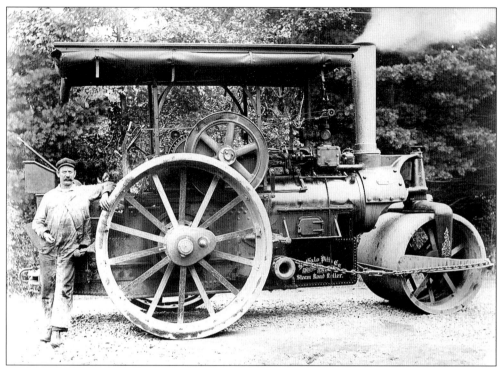

A Buffalo Pitt steamroller was used by the town to pack road surfaces. This photograph was taken in 1910.

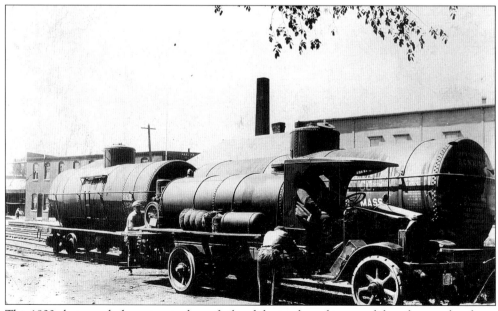

This 1922 photograph shows two tankers of oil and the truck used to spread the oil on road surfaces.

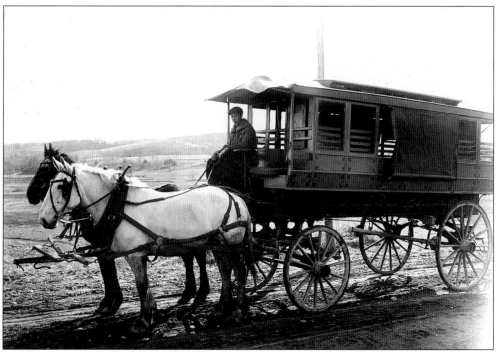

An early school bus, the Village Belle, was used to transport children from Hillsville. The driver in this photograph is Roy Parker.

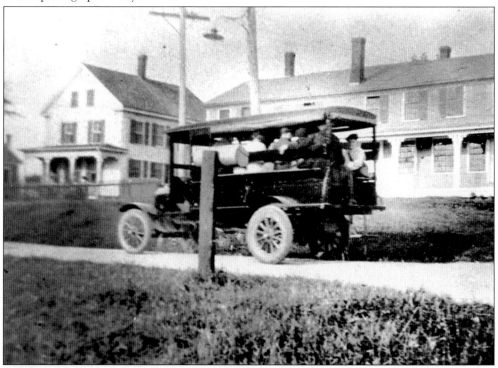

The modern school bus of 1920 allowed passengers to ride in comfort. The bus in this photograph is one of the first motorized buses in Spencer.

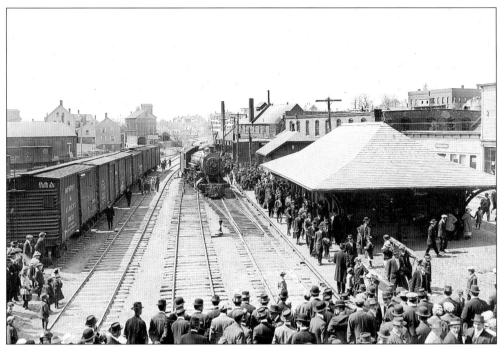

Hundreds of people await the arrival of a distinguished passenger at the depot on Wall Street. The building still stands, and one can purchase hot dogs at Artie's Famous Hot Dogs.

Charles M. Kane (left), Jane F.E. Kelly (center), and Sarah R. Kane await their ride at the South Spencer Depot.

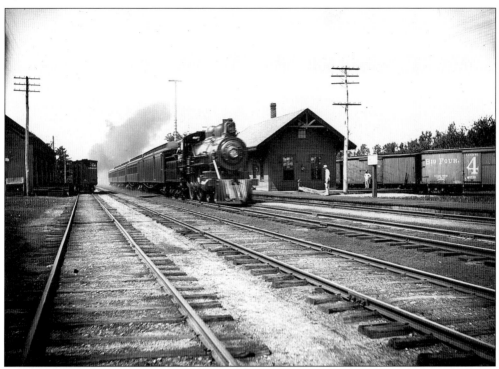

The train has arrived at the South Spencer Depot. The freight house can be seen on the left.

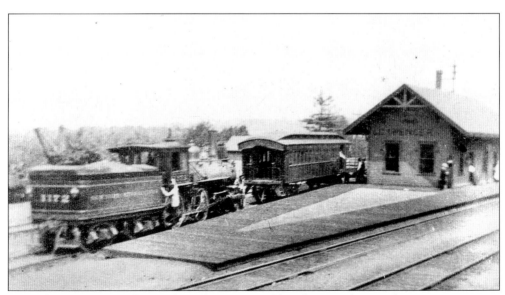

An early train waits at the South Spencer Depot. This photograph was taken *c*. 1862.

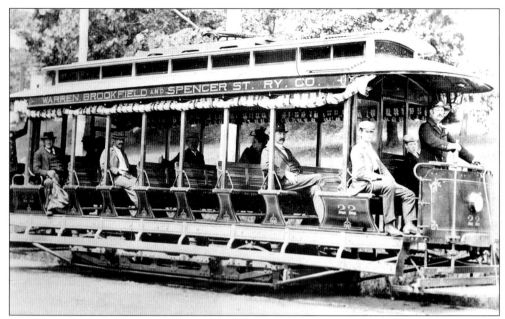

The Warren, Brookfield and Spencer Railway Company trolley is photographed near Emmett Street.

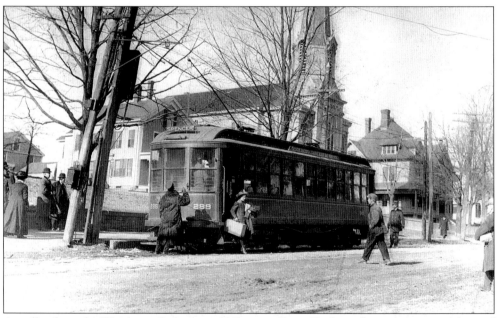

A trolley from the Worcester, Leicester and Spencer Street Railway Company stops in front of the Methodist church. Passengers traveling west had to walk down the hill from the town hall to the center of town and switch to the Warren, Brookfield and Spencer Street Railway Company trolley to proceed on their journey.

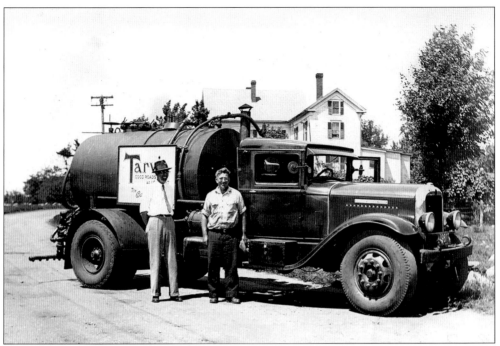

Highway superintendent Armand Jalbert (left) talks to a worker on Maple Street. The worker is about to spread oil with the Tarvia truck.

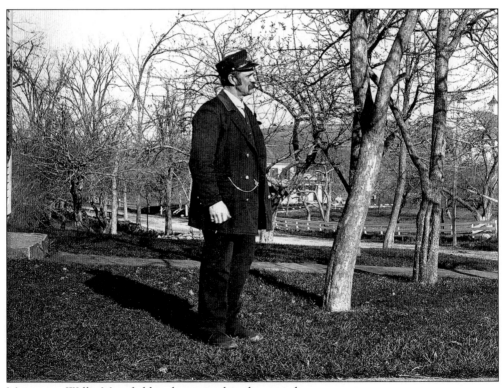

Motorman Willis Mansfield is shown in this photograph.

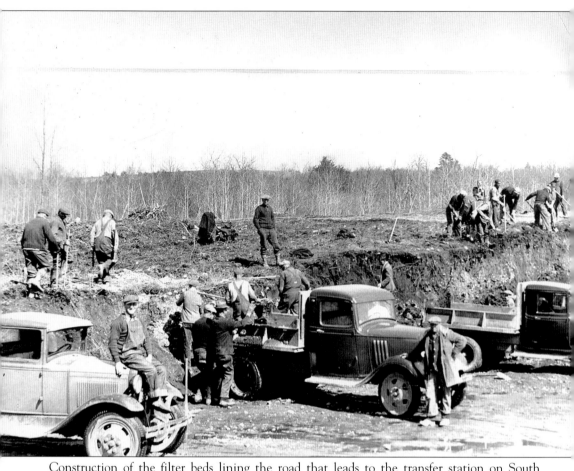

Construction of the filter beds lining the road that leads to the transfer station on South Spencer Road took place in 1934.

Four

SCHOOLS AND
CHURCHES

The first schoolhouse in the settlement of Spencer was constructed in 1764 on land owned by Jeremiah Whittemore. The land was located on the south side of the county road (Route 9), approximately one-half-mile east of Paxton Road. When this sketch was drawn, the building had been used for storage and fallen into disrepair. It eventually was torn down by Deacon Edward Proctor and G.J. Greenwood.

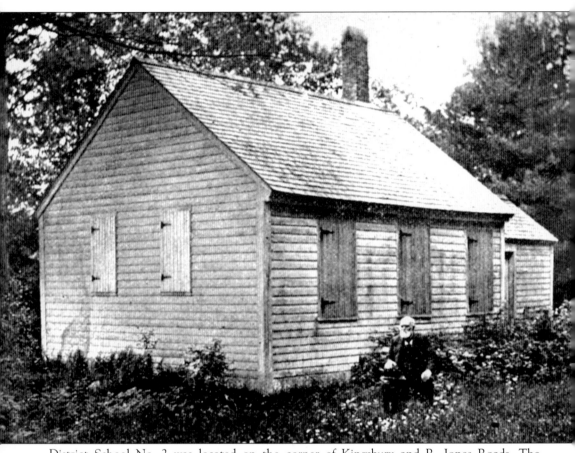

District School No. 2 was located on the corner of Kingsbury and R. Jones Roads. The gentleman seen here is George Washington Bemis, who attended school here.

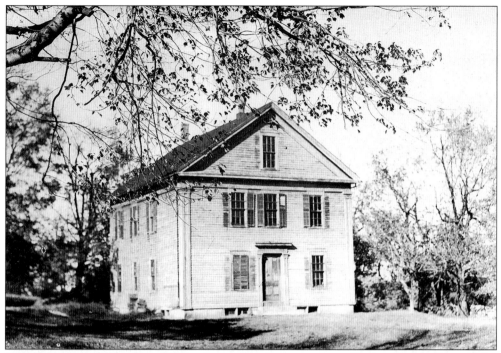

District School No. 3, built in 1856, is located on the east corner of Park and Main Streets. The building is still standing and is owned by Richard Green.

District School No. 4, built in 1847, stood on the south side of Gold Nugget Road and opposite of McCormick Road.

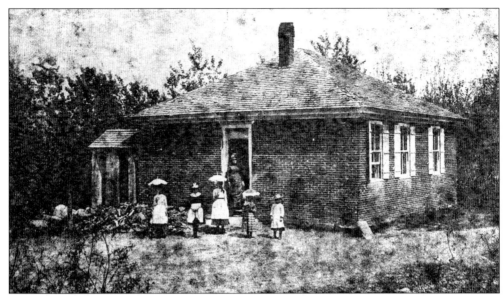

District School No. 5 stands back from North Spencer Road before the intersection of Thompson Pond and Browning Pond Roads. One of only two one-room schools, it closed in 1919 and is now a private residence.

District School No. 6 is located on Northwest Road. It closed in 1911 and was used as a clubhouse by the Northwest Farmers' Club. It is now a private home.

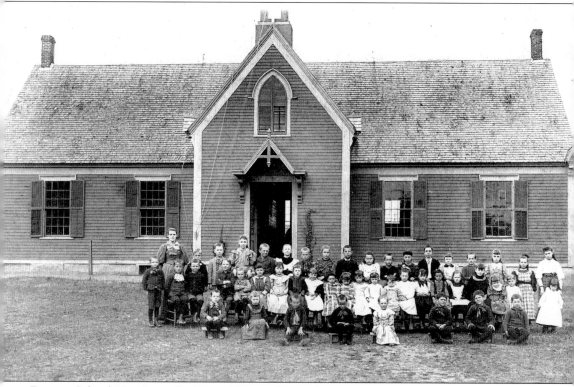

District School No. 7 was built in 1871 on the northwest corner of Northwest and North Spencer Roads. It closed in 1932 and is now a private home.

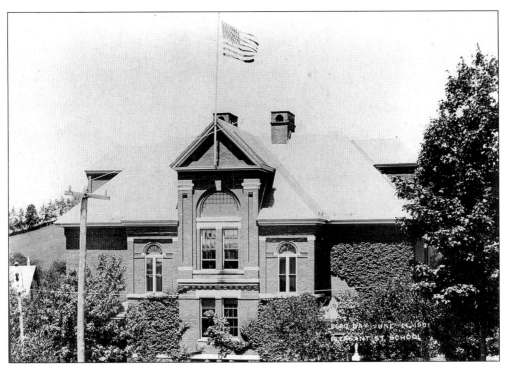

Pleasant Street School (District School No. 8) was built to replace an earlier building in 1884 for the sum of $10,940. It remained in use as a school until it closed in 1995.

West Main Street School (District School No. 9) is shown as it appeared in 1900. It is still used as a school today.

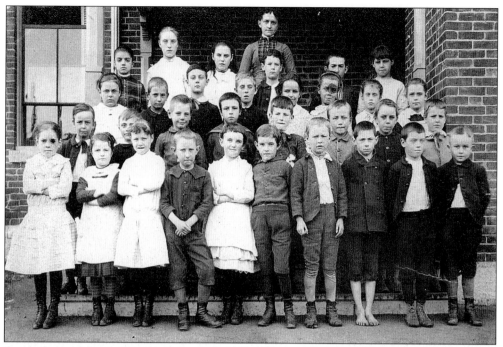

Grove Street School (District School No. 12) is shown in June 1885 with Carrie E. Muzzy's class on the front steps.

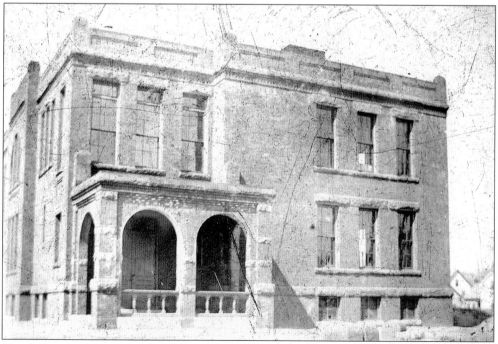

The Earley Street School (District School No. 14) was built in 1887, but by 1909 it had been replaced by other neighborhood schools. The town considered using the building as a home for the poor, but used it in the winter of 1919–1920 as a morgue. It was used by the highway department for storage until it was razed in the early 1930s.

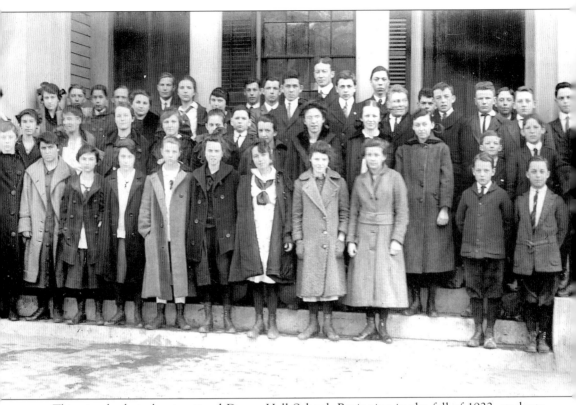

This was the last class to attend Denny Hall School. Beginning in the fall of 1922, students attended Maple Street School.

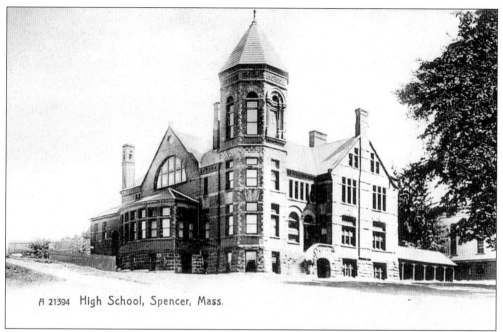

David Prouty Regional High School was built in 1888 for $45,000, which was donated by David Prouty, a prominent boot manufacturer. Note the horse shed next to the Congregational church.

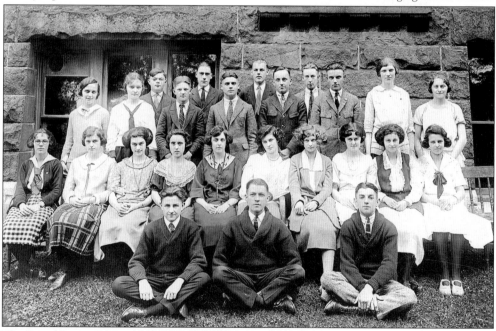

The David Prouty Regional High School Class of 1923 included, from left to right, the following students: (first row) Edward Lane, Armand Cantara, and William Collette; (second row) Anna Boucher, Myrtle Sullivan, Marie Cote, Gertrude Hiney, Wilrose LaPlante, Gladys Champoux, Rita Sebring, Eileen Crimmens, Lillian Cournoyer, and Pauline Sauve; (third row) Alice Conroy, Vera Rautio, Theo Hodgerney, Frank McQuaid, Walter Hurd, Roscoe Putnam, Lilia Sugden, and Helen Terry; (fourth row) Enoch Avelly, Edward Marsden, Rick Hobbs, and Roger Dickenson.

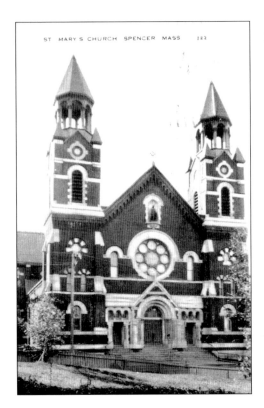

St. Mary's Church was dedicated in November 1903. At the time of dedication, construction was not complete.

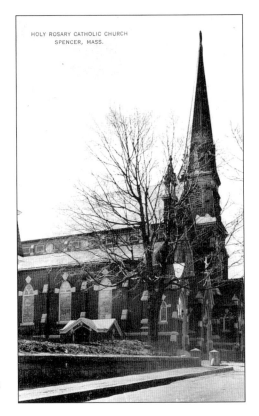

Our Lady of the Holy Rosary Church on Catholic Street, now called Church Street, was dedicated on the first Sunday of October 1887.

The First Congregational Church is shown before 1885, when an addition to the rear of the church was completed. The addition added 40 feet to the length of the church.

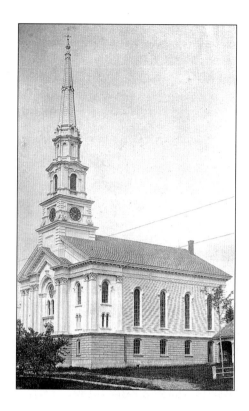

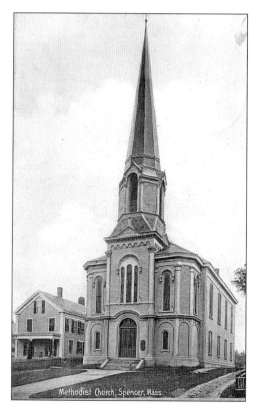

Methodist Church, Spencer, Mass.

The Methodist church on Main Street was built in 1847. A fire destroyed the church on December 13, 1943. The church was rebuilt and, after many years, was topped off with a new steeple.

63

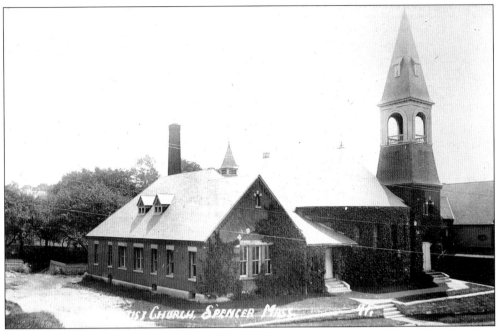

Built in 1883 by Stephen C. Earle, noted architect at that time, the Universalist church is located on Linden Street. Sold to the Allen Squire Factory in 1936, the building is still used by the Saad Company.

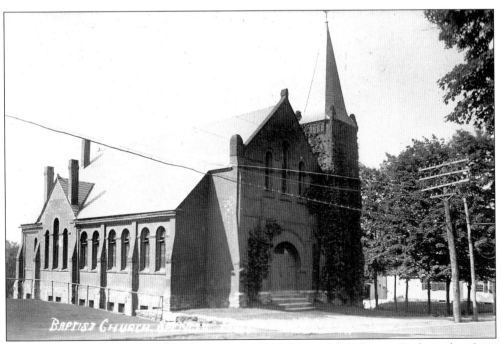

The Baptist church was located on the east corner of Main and Ash Streets. Dedicated on June 21, 1887, the building was razed in 1939. A private residence now sits on the site.

Five
SPORTS

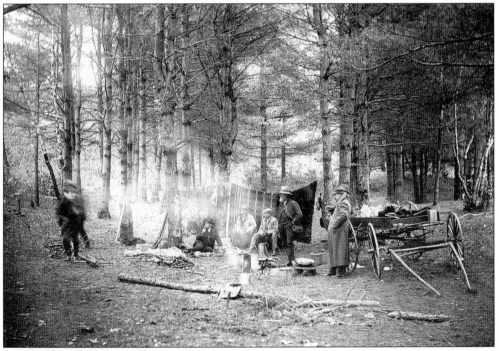

A photograph of Camp Honey by Brooks Pond, taken on October 18, 1898, shows a group of men actively trying to provide for their families. Leaning against a tree are two guns, and hanging from another tree is a fish creel.

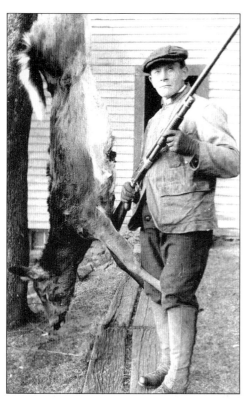

Cornelius "Con" Begley stands beside the deer he took while hunting in South Spencer.

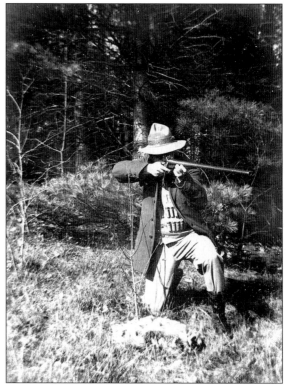

The nimrod shown is Edmund Collette, hunting in Howe's Meadows, now Howe State Park, on November 1, 1910.

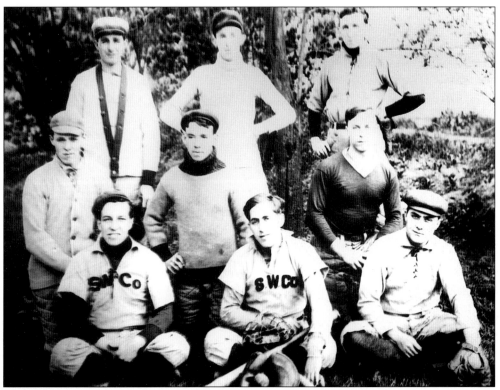

The Spencer Wire Company baseball team poses for a *c.* 1900 photograph.

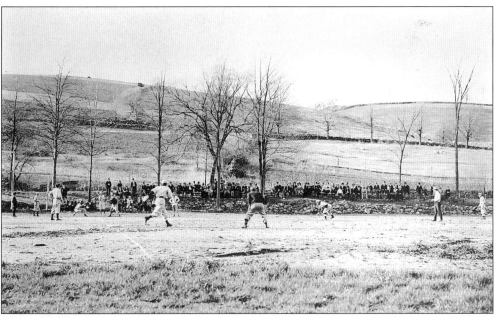

The Spencer Wire Company baseball team plays on the field owned by the company at the corner of Wire Village Road and Gold Nugget Road.

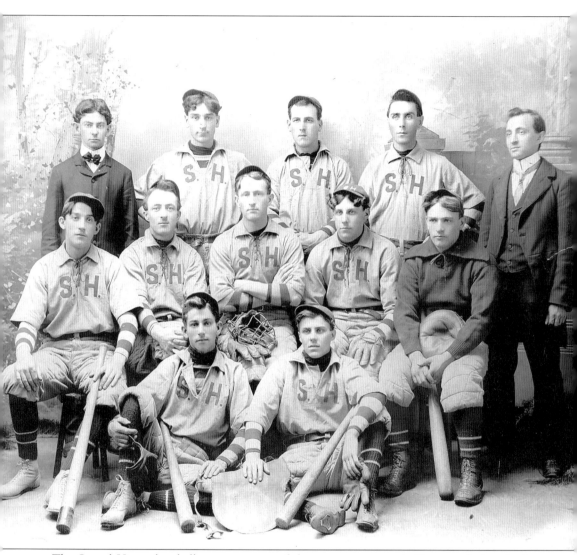

The Sacred Hearts baseball team was one of the strongest teams in Spencer during the late 1890s. In 1901, they played the Spencer Wire Company team in front of 3,000 fans. They were beaten by the wire company 2-1.

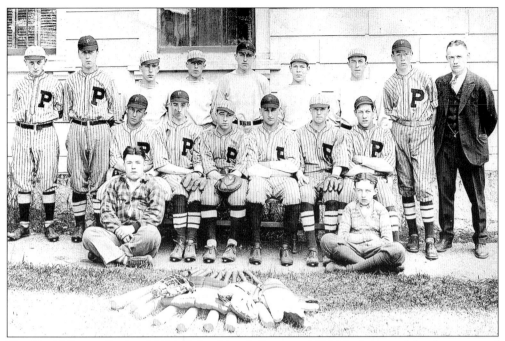

The David Prouty Regional High School baseball team of 1926 had a record for the season of 12 wins and 4 losses.

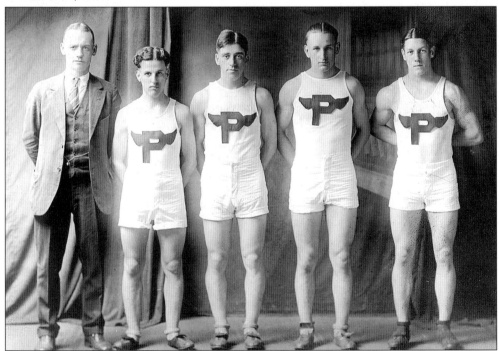

In this photograph are members of the 1926 David Prouty Regional High School track team. Seen here are, from left to right, H.S. Newell (coach), P. Quinn, F. Meloche, U. Beford, and G. Morin. This team won the 880-yard relay and the Southern Worcester County championship on June 12, 1926, with a time of 1:41.

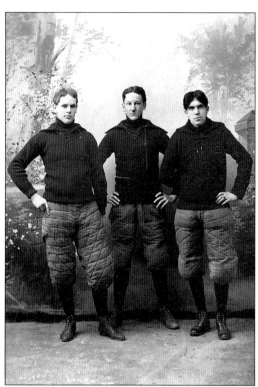

Del Hobbs (left), Fred Ames (center), and Ray Bullard were members of the 1899 David Prouty Regional High School football team.

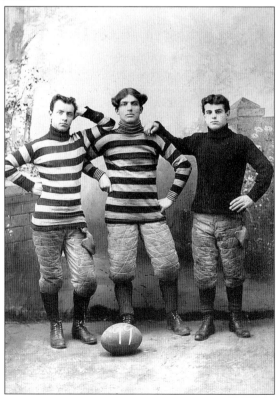

Three more members of the 1899 David Prouty Regional High School football team are shown. The player on the right is Joe Bourdages.

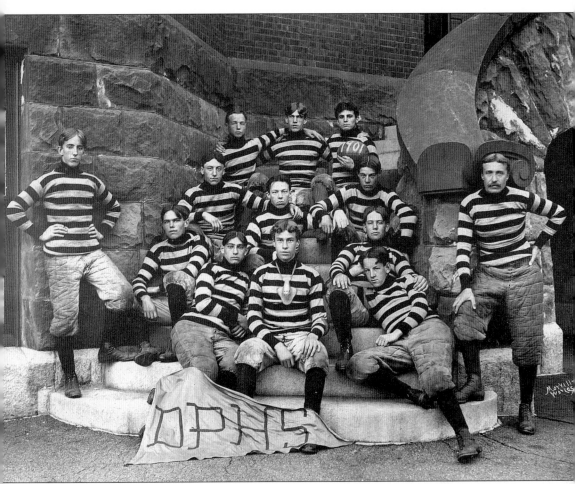

This photograph shows the 1901 David Prouty Regional High School football team. Note the padded quilt pants. The athlete on the right was a member of the faculty who was allowed to play.

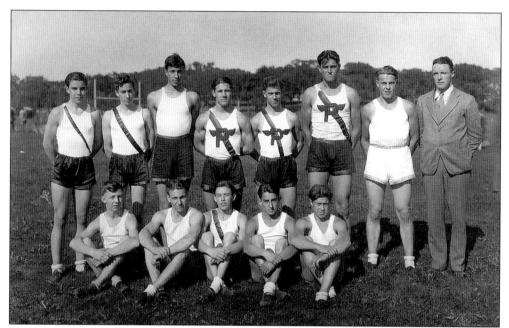

The members of the Prouty track team of 1930 seen here are, from left to right, the following: (front row) Ernie Roberts, Gene Christian, Sumner Putnam, Roland Gaudette, and Jack St. Germain; (back row) Flash Gaudette, Romeo Gaucher, Gordon Whitcomb, Alfred Morin, Ray St. Germain, Pete Ruskowski, Bernie O'Janne, and Edward R. McDonough (coach).

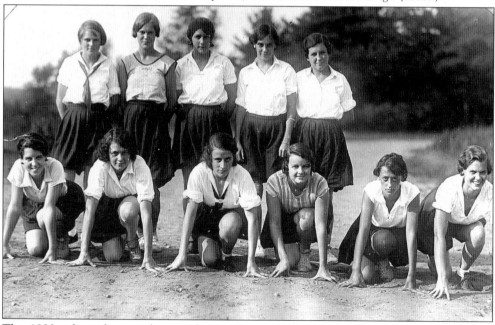

This 1930 girls track team photograph was taken at O'Gara Park. The athletes seen here are, from left to right, the following: (front row) Olive Holdroyd, Viola O'Coin, Elizabeth Green, Kathryn Toomey, Claire Benoit, and Jessie Gibson; (back row) Lillian Connors, Dorothy Lyford, Helen Gendreau, Ethel Cournoyer, and Blanche Aucoin. Two years later, Dorothy Lyford would jump 8 feet, 3³/₁₆ inches in the standing broad jump to claim the world record.

Six

PARADES

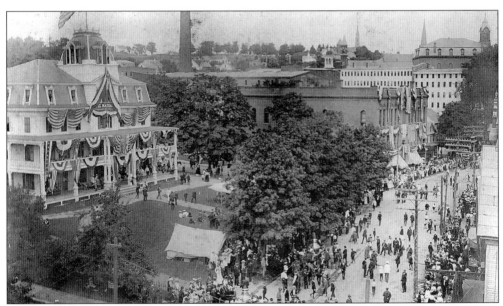

Muster Day in Spencer was August 24, 1901. Nearly every house and business was adorned with the red, white, and blue colors of the country. This was one of the largest fire department musters of its time with 43 fire departments marching and competing. Along with floats and over 2,000 marchers from all walks of life, eight bands marched in the parade. It is reported that over 6,000 visitors were in town to take part in the festivities. The local restaurants and saloons are said to have done a brisk business. It is quite probable that this was the biggest one-day celebration the town has ever seen.

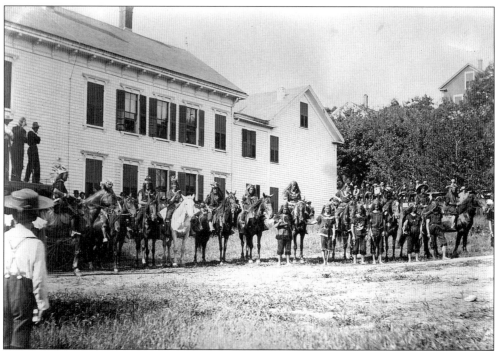

The Ambrose "Chip" Fox Native Americans represented a tribe of Nipmuc Indians. They were prizewinners in the 1900 Fourth of July parade.

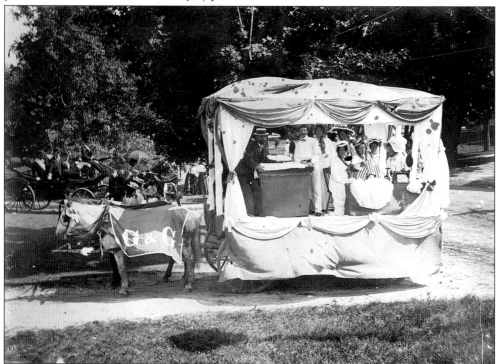

The Green & Green Underwear Factory float was voted best trade float in the Fourth of July parade of 1900. Note the sewing machine being used.

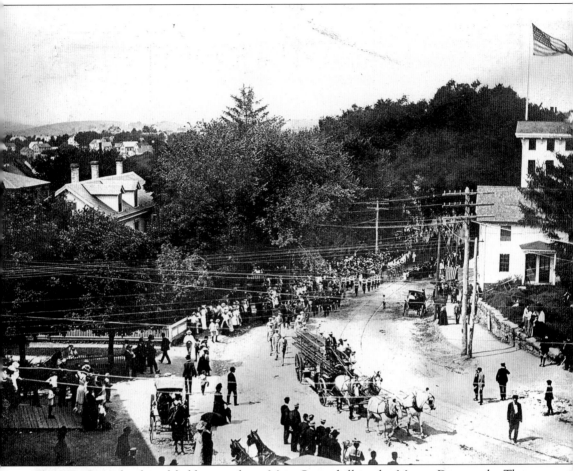

The J.N. Grout hook and ladder travels up Main Street hill in the Muster Day parade. The parade was over one mile in length.

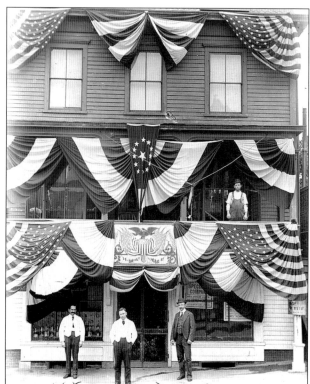

This is only one of the many stores decorated for Muster Day.

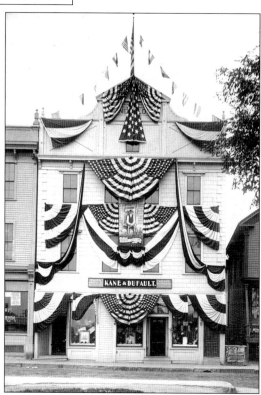

The Kane Block on Mechanic Street was decorated for the Muster Day parade.

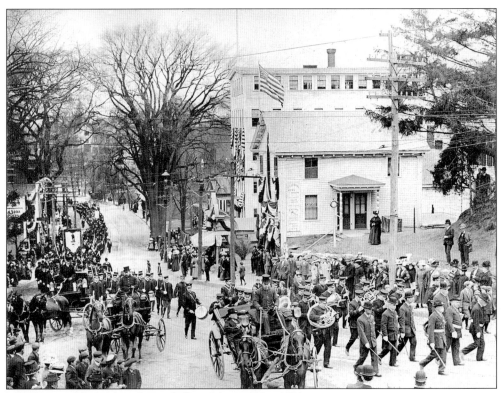

Marchers come up Main Street hill on Muster Day, 1901.

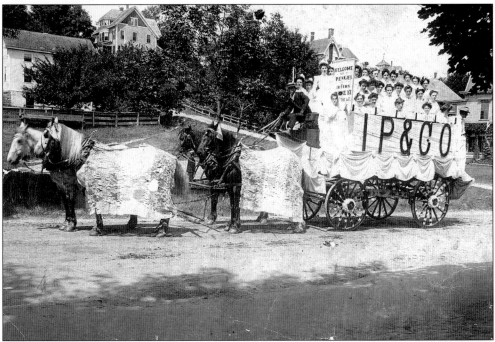

The Isaac Prouty Company's float was a part of Spencer's first Old Home Day in August 1902. They are lined up by the corner of Pleasant and Prouty Streets.

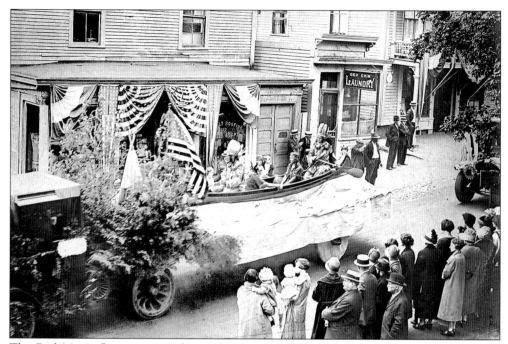

The Red Men's float passes in front of Tim Mack's five-and-dime store and George Chin Laundry on Mechanic Street in 1916.

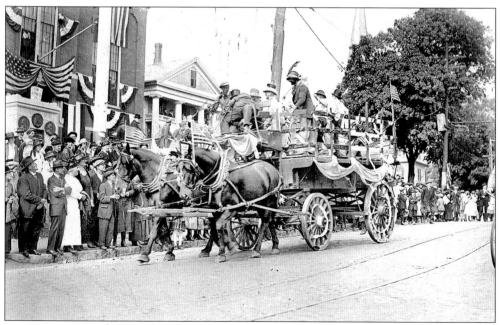

A 1919 float that celebrates the returning veterans carries a group of men wearing feathered hats.

78

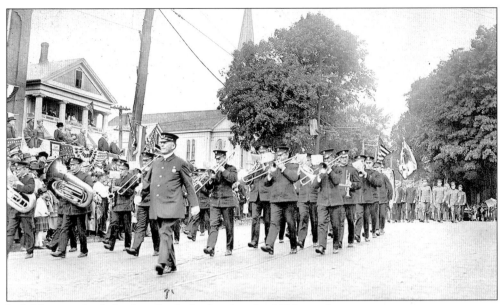

Jack Norton, chief of police, leads the band in the 1919 parade.

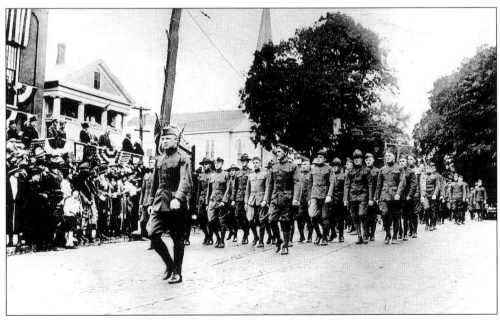

World War I veterans march in the parade on September 20, 1919.

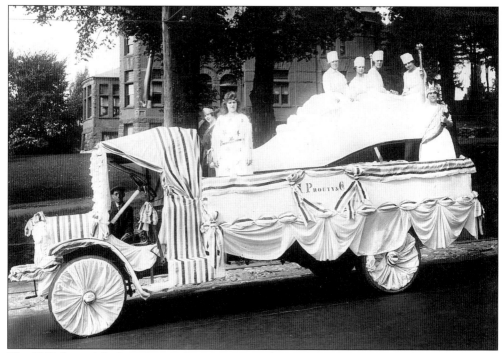

The 1919 float of the Isaac Prouty Company sits in front of David Prouty Regional High School.

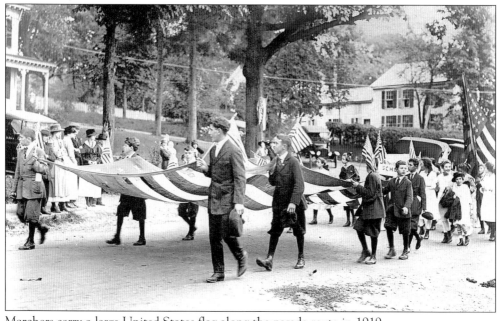

Marchers carry a large United States flag along the parade route in 1919.

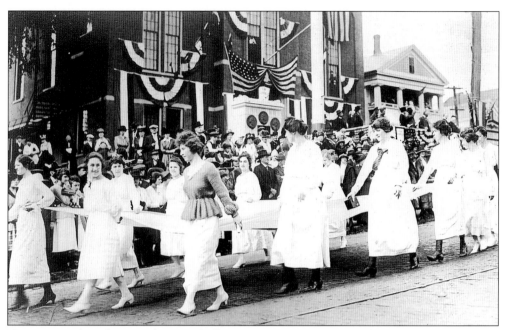
Nurses carry their flag past the town hall in 1919.

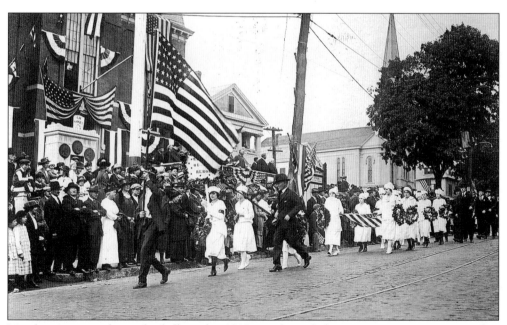
Marchers coming down the hill in the 1919 parade include a woman carrying a sign that proclaims "thanks to the heroes."

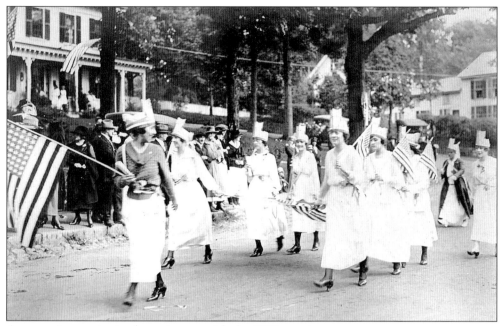

A woman's organization keeps in step with the 1919 parade.

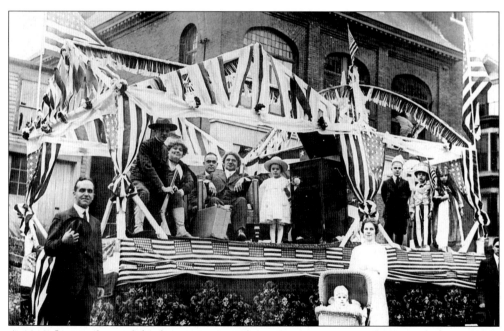

A 1919 float in front of the fire station on Cherry Street seems to reflect many time periods. Note the wind-up record player in the center and the young Uncle Sam on the right.

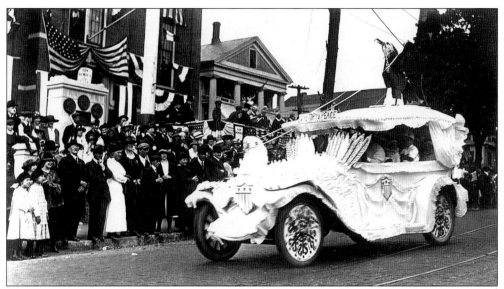

A float with a dove on its front and "Victory and Peace" above its windshield passes the reviewing stand in the 1919 parade. Above the Howe memorial is a sign reading "Our Heroes."

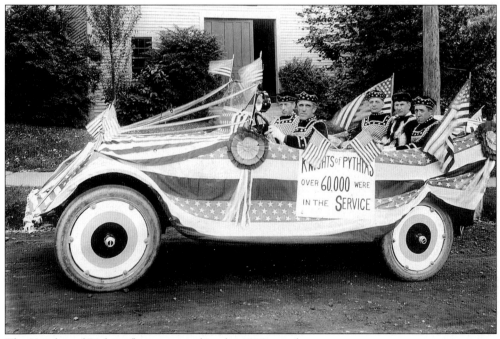

The Knights of Pythias float appeared in the 1919 parade.

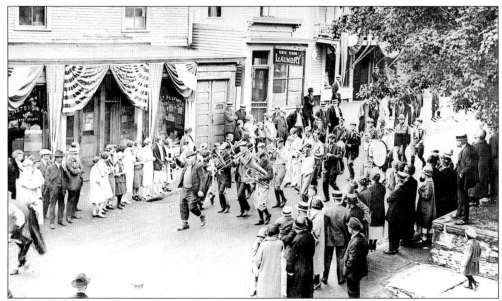

The high school "hobo band" marches in the July 4, 1925 parade. The major leading the group of Prouty band members is Norman Burkill. Other members of the band in the "horribles" section include the following: Robert Taylor, alto; Robert Skaife, cornet; Lawrence Wallie, baritone; Everett Doane, clarinet; Edward Reavey, saxophone; Clifton Hutchins, bass; Arthur Baril, cornet; Earl Willey, cornet; Charles N. Prouty, saxophone; Al Reavey, cymbals; Edgar Phaneuf, trombone; Roland Maynard, saxophone; Hollis Vernon and Russell Hitchins, drums; and George Tower, clarinet.

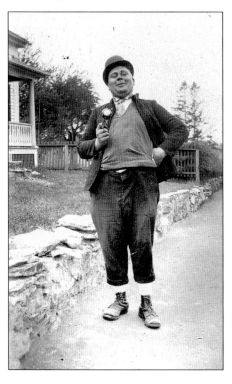

Norman Burkill proudly poses as the lead "hobo."

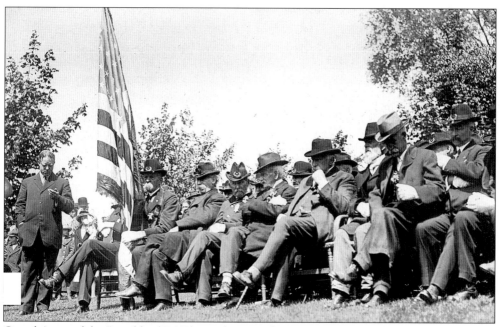

Grand Army of the Republic (GAR) members are shown at a Memorial Day ceremony, held at the Lothrop Prouty Park in the mid-1920s.

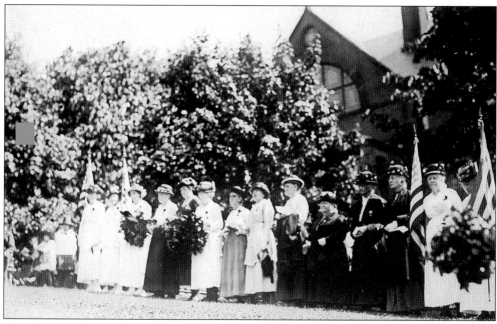

The Women's Relief Corps No. 125 prepares to place wreaths on the markers of the fallen soldiers. The group disbanded in 1937.

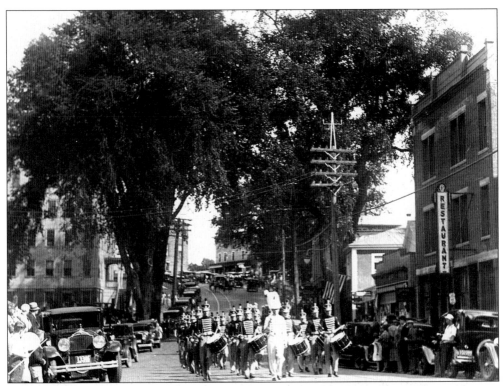

A marching band comes down Main Street through the center of town during the 1930s.

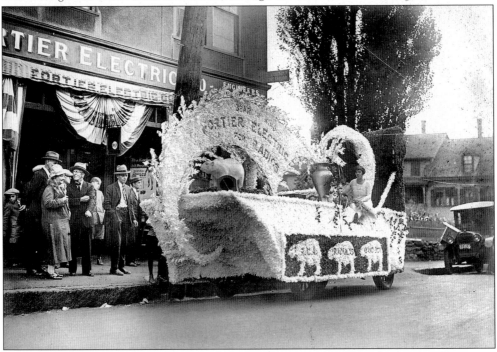

Seen here is the Fortier Electric prizewinning float during a 1925 parade. Fortier Electric was the first store to sell radios in Spencer.

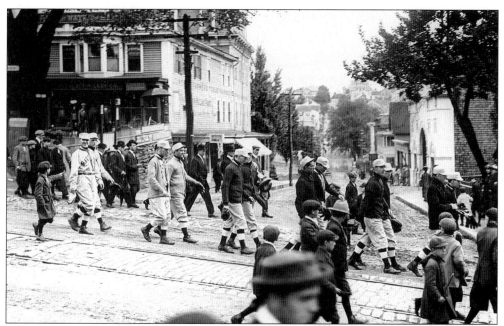

The Matchless baseball team marches past Mechanic Street. Notice the trolley tracks and the cobblestones.

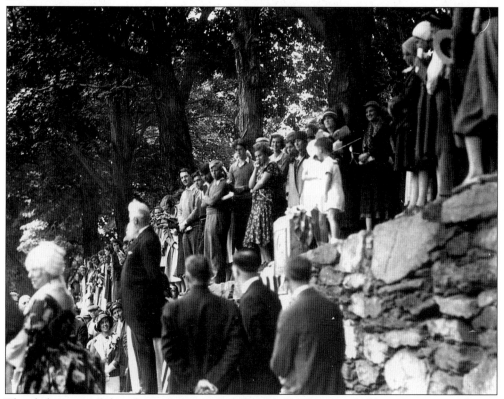

The dedication of the plaque honoring George Washington was held on June 2, 1932, as a celebration of the bicentennial year of his birth.

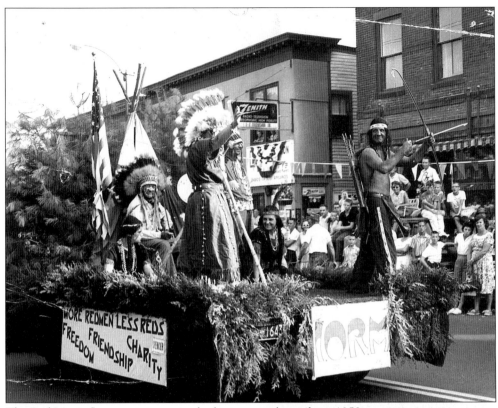

The Red Men's float participates in the bicentennial parade in 1953.

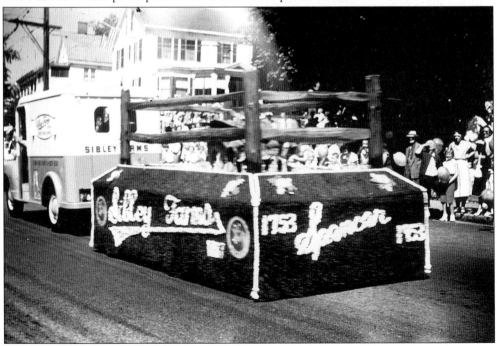

The float representing Sibley Farms was a part of the 1953 bicentennial parade.

Seven
STREET SCENES AND DISASTERS

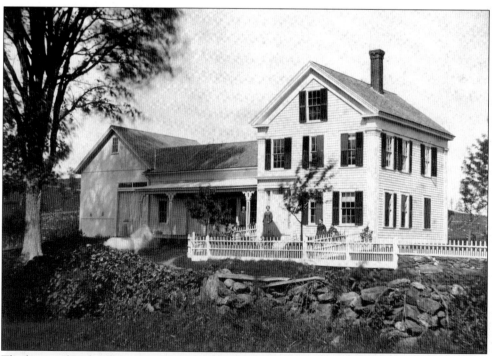

The home of Richard Sugden was located at 51 Gold Nugget Road. He ran wire mills in Wire Village and gave Spencer the library and the block that bear his name. In the photograph are Richard Sugden, his wife, Mary Walkden Sugden, and their daughter Emma, who later married Noah Sagendorph.

This photograph shows the tranquil Muzzy Meadow Pond on Maple Street.

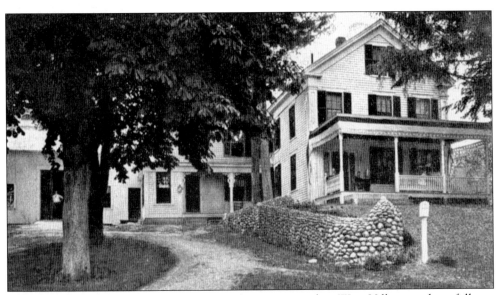

The back of this picture postcard of the Jecher Homestead in Wire Village reads as follows: "The prettiest resort in New England. Highest elevation between Boston and Springfield. A modern house with the products of a fine farm. Pure spring water. Open April 1 to Nov. 1."

In a view looking east up Main Street hill, the Bank Block and Union Block can be seen at the top of this photograph.

Standing on the lawn in front of the Massasoit Hotel, one was greeted with this view of Spencer center. Pleasant Street is on the left just before the house. The sidewalk leading to the hotel is constructed of wood, and the business district had few stores.

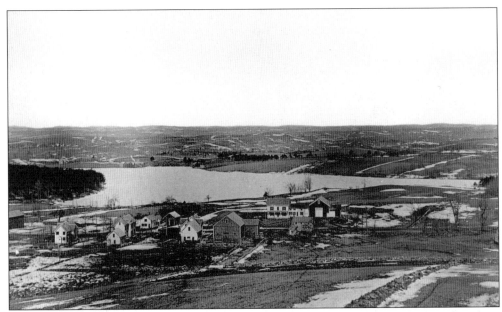

This *c.* 1900 photograph of Lake Whittemore and its surrounding countryside was taken from Moose Hill. The grove of trees on the left shore of the lake is where the Luther Hill Public Park is now located.

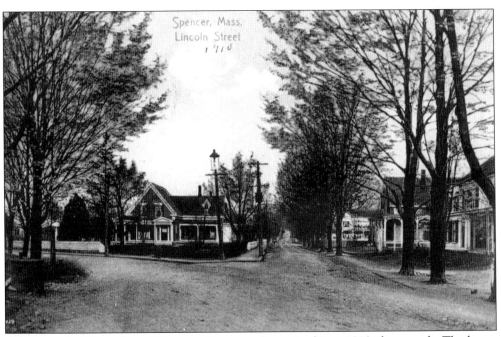

The junction of Lincoln and Pleasant Streets is shown in this *c.* 1910 photograph. The home in the center, behind the gas street lantern, was once the home of historian Henry M. Tower and later belonged to publisher William T. Heffernan.

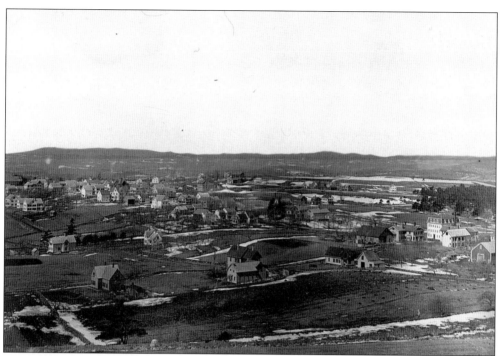

In a view looking northwest from Moose Hill, it is evident how open Spencer used to be. Most of the trees visible are apple trees in orchards.

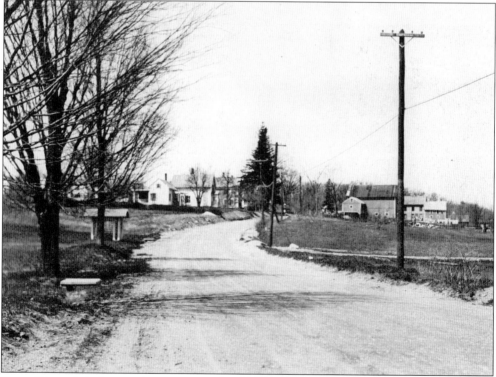

Route 31 north is shown where it approaches North Brookfield Road.

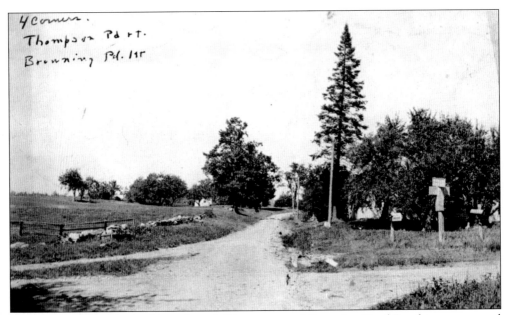

The intersection of Route 31 north with Thompson and Browning Pond Roads was very rural and narrow.

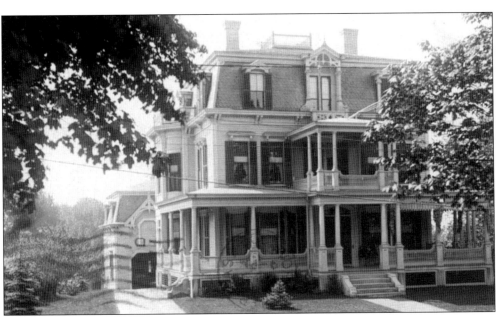

The Lewis Dunton House at 204 Main Street is used today as a rooming house.

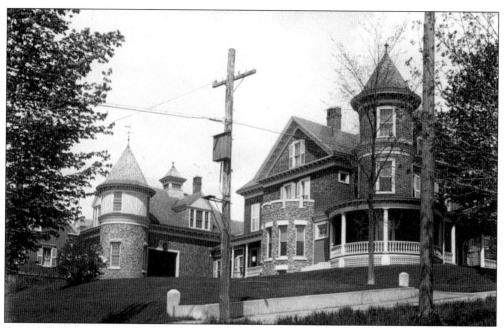

Originally the property of Richard Sugden, the Arthur Sagendorph house on High Street was purchased in late 1902 and completely remodeled.

In a view looking north on Grove Street, Grove Street School is shown before the second floor was added.

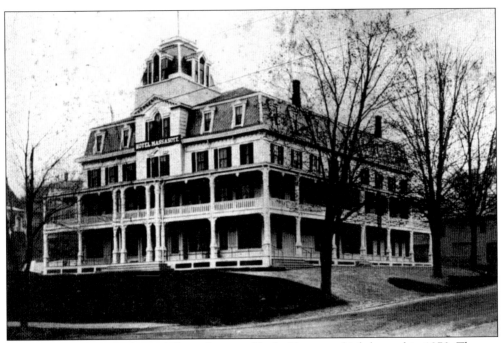

Massasoit Hotel was built in 1873 on the site of Jenks Tavern, which burned in 1870. The top floor was destroyed by fire in 1910. Various owners ran it until the Quinn family bought it in 1911. It was completely destroyed in a spectacular fire on January 12, 1982.

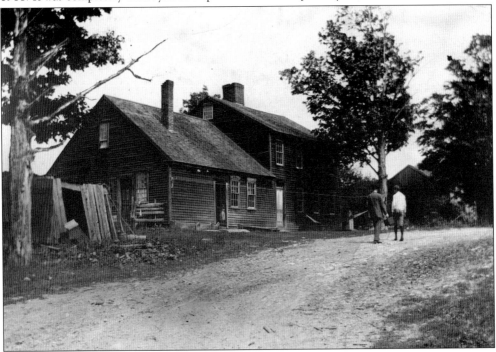

The home of Elias Howe Jr., the inventor of the lock stitch sewing machine, was built by Luke Converse in 1759. Elias Howe Sr. put on an addition in 1816. The home was torn down in the early 1900s, but is commemorated by a monument in Howe State Park.

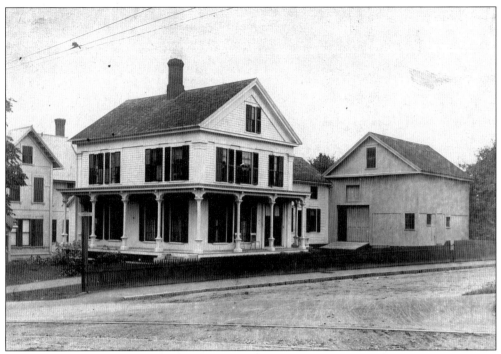

The David Prouty house, located at the corner of Main and Grove Streets, is now the home of the American Legion.

The American Legion is shown as it appeared in 1921.

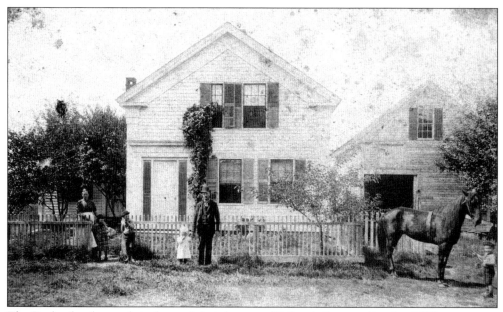

The Begley family stands in front of their home at 82 South Spencer Road *c*. 1890.

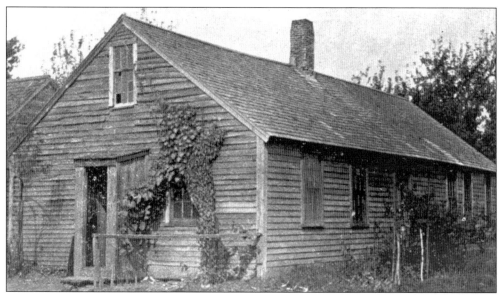

The home of Capt. Edmund Bemis is shown in this photograph. Bemis was the son of Samuel Bemis and a hero at the capture of Fort Louisburg at Cape Breton in the French and Indian War.

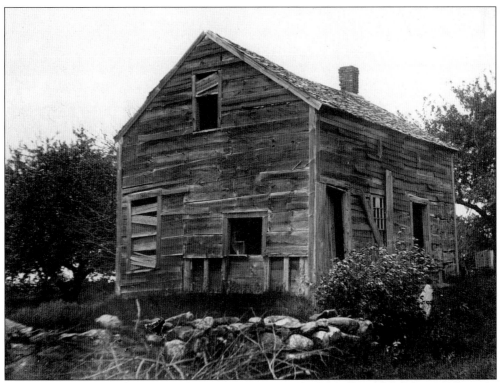

Isaac's Prouty's first boot shop stood on the corner of North Spencer and Browning Pond Roads.

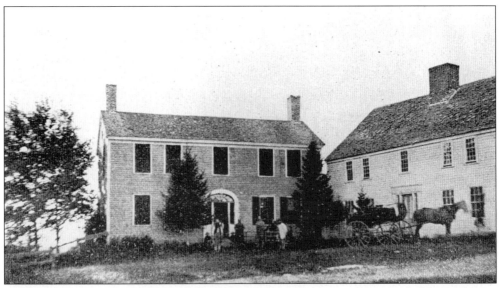

When he first started making boots, Isaac Prouty lived in this *c.* 1810 North Spencer home. Archibald Lamson, a Scotch-Irish immigrant, built the house on the right *c.* 1740.

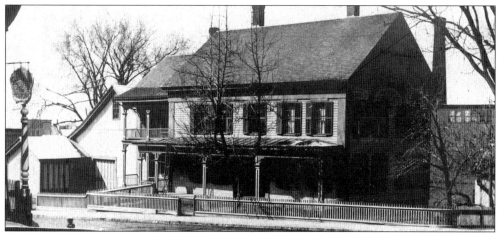

The home of Everett Prouty is located on the west corner of Mechanic and Main Streets.

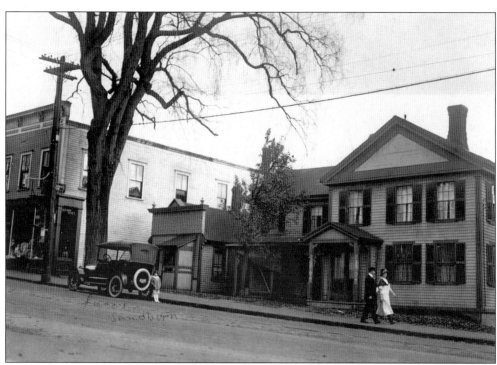

Dr. Frederick Sanborn's house was located on Main Street. His son, Lawrence, is best known to Spencerites as the composer of the school song for David Prouty Regional High School.

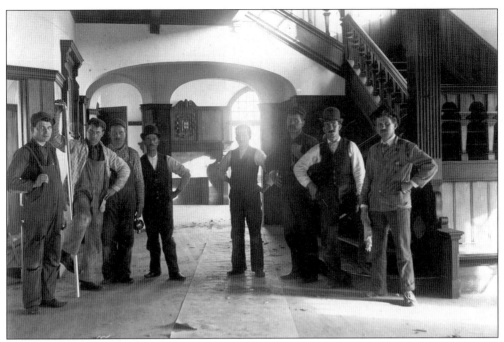

Workmen pose inside the Sibley mansion. No effort was spared to build the interior. A depression occurred during this time and townspeople appreciated the employment given to the local workers.

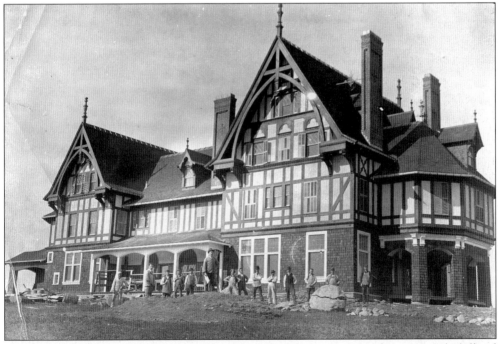

The Sibley mansion was nearly finished in 1899. It had 52 rooms, 2 dining rooms, and a billiard room. It was empty for a decade. John R. Sibley tore it down in 1939 after the 1938 hurricane damaged the roof and windows.

The William May place stood near 121 Hastings Road and was built in 1742. David May, son of William, was involved in Shay's Rebellion and was sued by Dr. David Young, who received a bad wound in the knee in the battle of New Braintree.

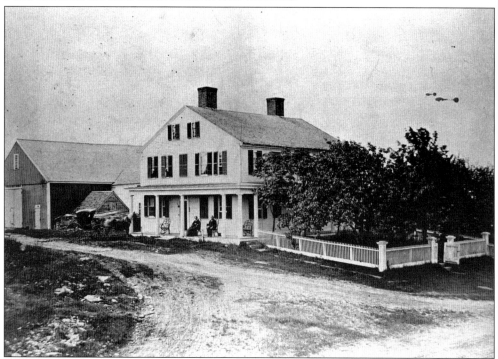

The Josiah Green home stands at the corner of Main and Greenville Streets. Green was the first boot maker in Spencer. His shop was located directly across Main Street.

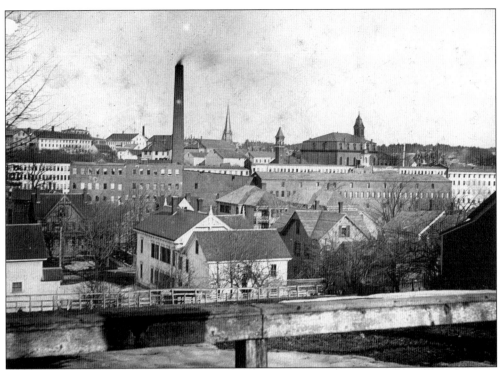

This view of Spencer looks southeast from High Street. Note the Isaac Prouty Boot Shop and the second town hall.

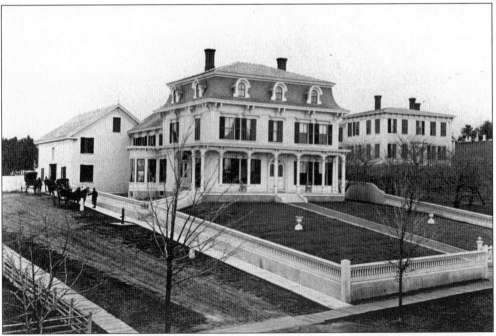

The Hezekiah P. Starr home stands in the center of this photograph. The next house to the right, the Nathan Hersey home, was moved to 221 Main Street. The original Hersey site is now the Lothrop Prouty Park.

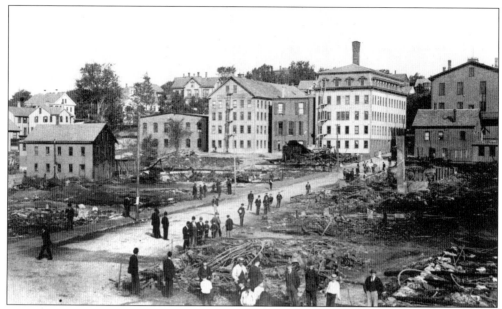

On September 13, 1893, a large part of the central business district was destroyed. A fast-moving fire destroyed a total of six acres of business buildings. This view north up Wall Street shows some of the destruction. Flexcon now has a building on this corner.

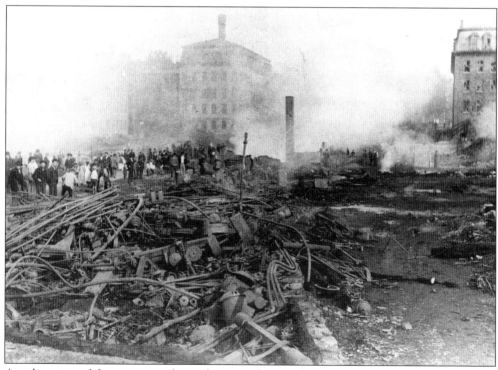

Another view of the same area shows the twisted ruins of local industry.

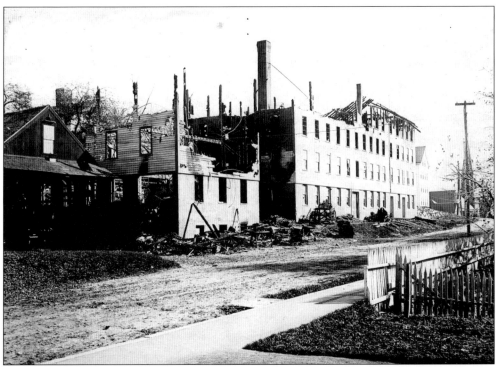

Seen here are the remains of the Bullard and Temple Boot Factory, which was destroyed in an October 1900 fire. This building was located on the east corner of Grove and Main Streets. Currently, there is an optometrist's office on the corner and a private residence next to it.

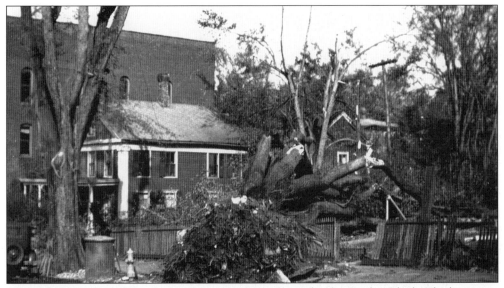

Giant elm trees shaded the center of town on Main Street by the Sugden Block. The hurricane of 1938 destroyed them.

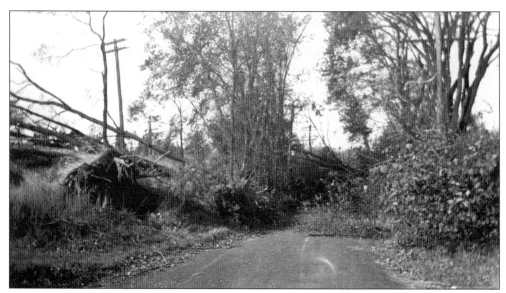

This photograph offers a view looking toward the South Spencer Road underpass after the hurricane of 1938.

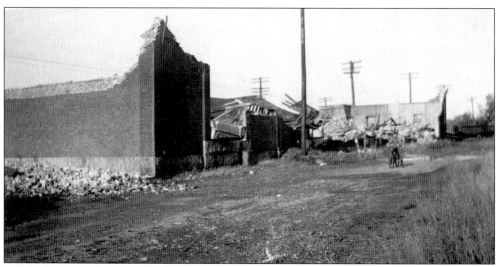

The Boston & Albany Railroad yard in South Spencer was destroyed in the hurricane of 1938.

Eight

PARKS AND RECREATION

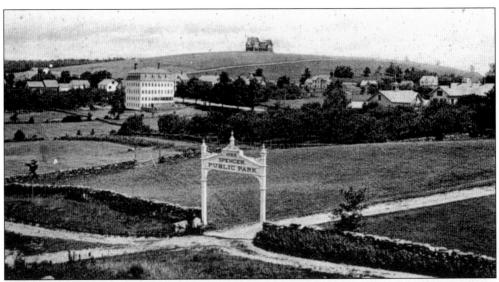

Looking toward the southeast from the entrance to the park on Green Street, now known as Park Street, the Josiah Green Boot Company building and the Sibley house sit on top of the hill where the high school soccer fields are now located.

Judge Luther Hill was very prominent in many aspects of Spencer's history.

Luther Hill Public Park was a gift to the town from Judge Luther Hill in 1887. He purchased the land for the town and donated it for the recreational use of the townspeople.

108

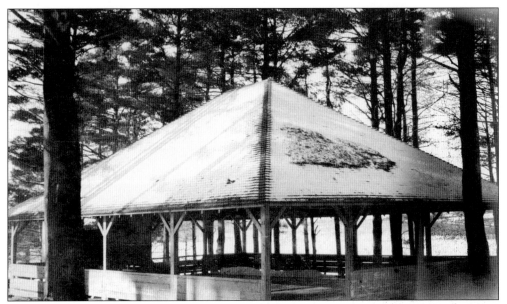

The pavilion was built in the park in 1888 for people to enjoy dancing and social gatherings.

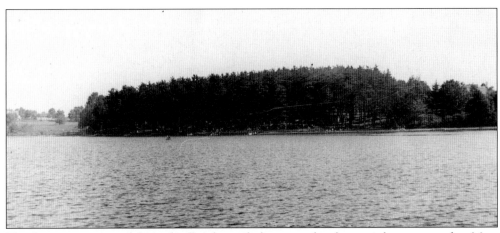

The dense pine grove of the park offered a cool place to seek refuge on a hot summer day. Most of the pine trees were left intact during the development of the park road and beach area.

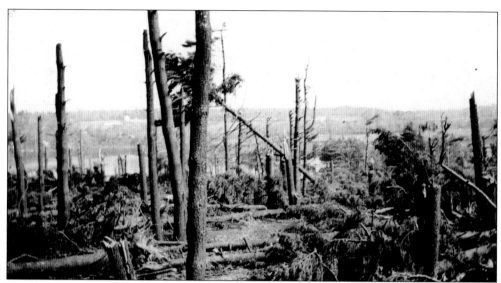

Most of the beautiful pines of the park were destroyed during the hurricane of 1938. The area was cleaned up and a new pine forest has grown.

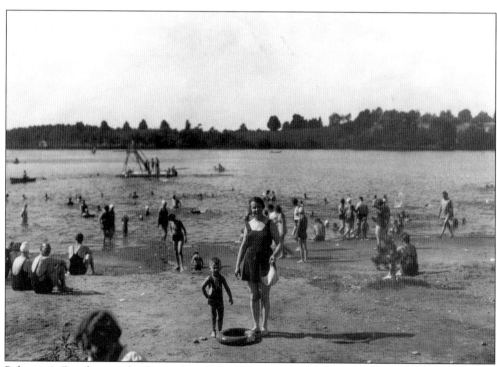

Peloquin's Beach was also located on Lake Whittemore, with the access road being what is today called Roy's Drive.

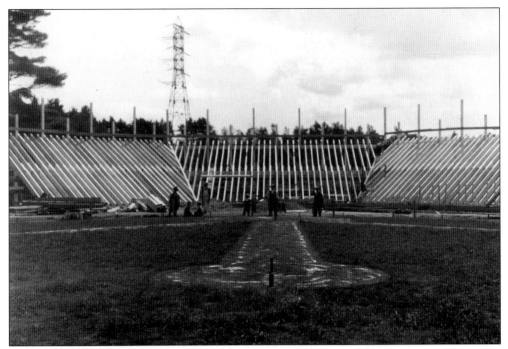

Originally called Railroad Park, O'Gara Park is located at the end of Valley Street. This 1930s photograph shows the construction of the grandstands behind home plate.

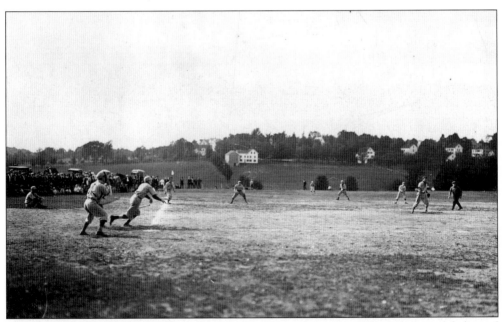

The Matchless baseball team plays at Railroad Park, later known as O'Gara Park, and dedicated in 1934 as the Spencer Athletic Field.

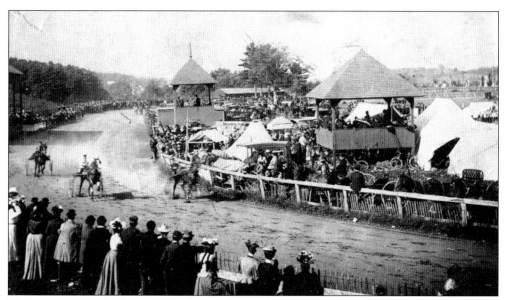

Harness racing took place at Myrick Park during the Spencer Agricultural Fair *c.* 1910.

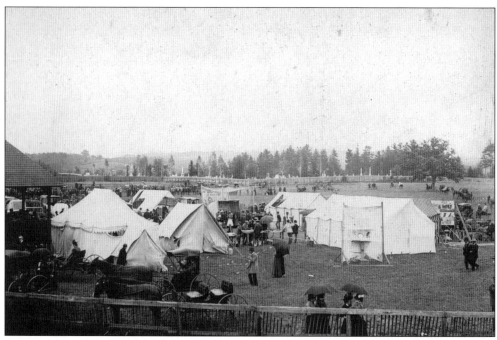

Some of the exhibits and food tents at the fair are shown in this photograph. Note the Pine Grove Cemetery behind the tents.

Nine
PEOPLE

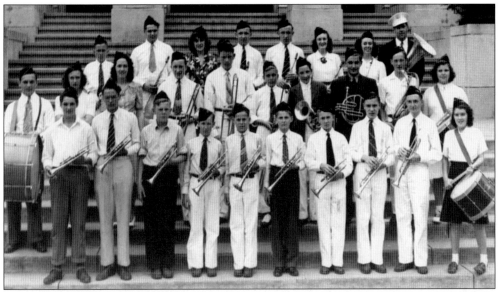

In this *c.* 1943 photograph are the David Prouty Regional High School Band members. Seen here are, from left to right, the following: (first row) Leon Hickney, Ray Lacroix, Gordon Johnson, Emery Villandre, Al Bouley, Jerry Newell, Richard Foisy, Donald Mills, Emile Ramm, and Mary Ann Bouley; (second row) Bud Ensom, Shirley Ginter, Theresa Landroche, Regis Breault, John Scanlon, Robert Snow, William Johnston, Ray Makynan, Richard Lumb, and Roberta Kenward; (third row) Dorman Elliot, Paul Emond, Rosalie Ryant, Jack Rogan, William Rogan, Lucille Breault, Lorraine Thibeault, and Howard Barre.

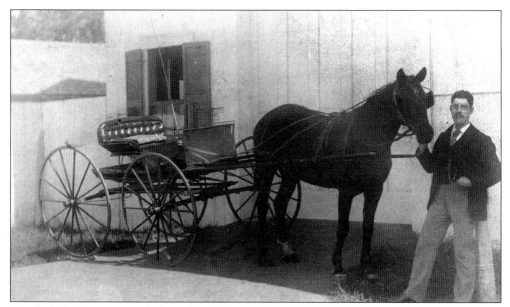

Hezekiah P. Starr gets ready for a drive.

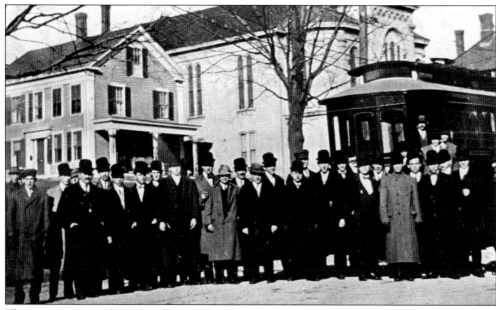

The inauguration day of trolley service between Spencer and Worcester took place on September 8, 1891.

With Merry Legs pulling, Janet Sagendorph (left), Red Madden (standing), and Ernie Roberts go for a ride in 1925.

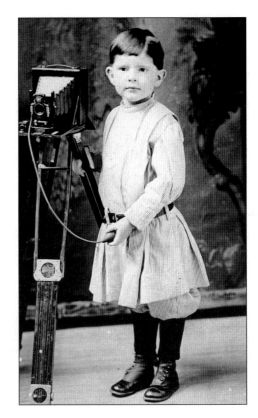

Everett Doane took many pictures of the town and townspeople over the years. This could possibly be his first photograph shoot.

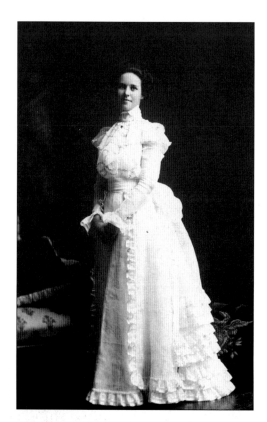

Martha (Page) Sagendorph, of the 1899 graduating class, is shown in her high school graduation picture. The dress in the photograph is on display in the museum in the library.

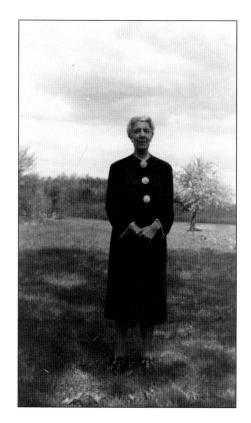

Dora Hodgon was the librarian from 1919 through 1946.

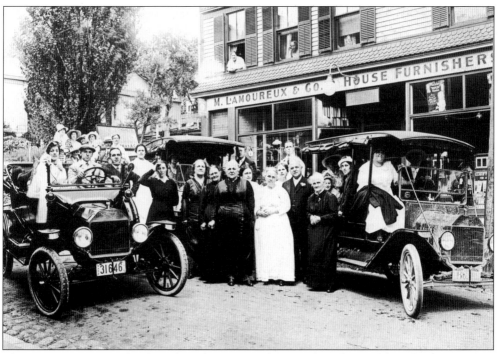

The Moise Lamoureux family gathers for a group photograph in front of their furniture store.

E. Ellsworth Dickerman ran the
newsroom on Main Street.

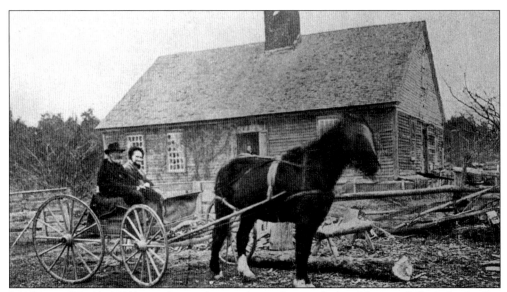
Ruel Jones (1813–1888) was a farmer, but was better known for his debating skills. Judge Luther Hill is said to have feared him more in open debate than any other man in town.

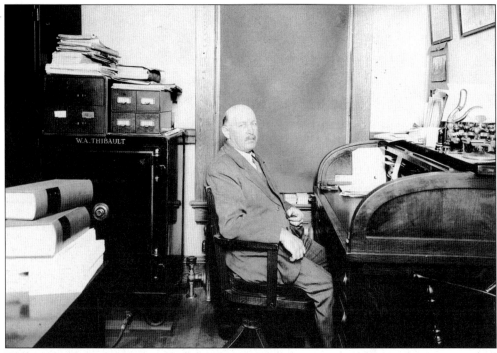
William A. Thibault was town clerk for 27 years. Here, he sits in his office in the new town hall in 1930.

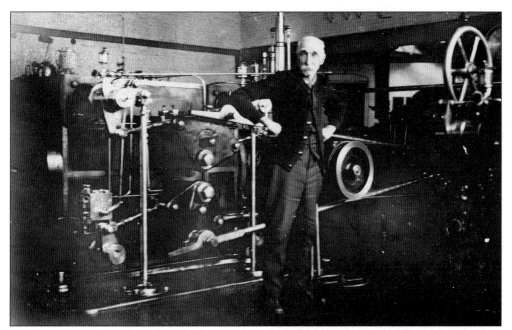

Henry Woodis is shown hard at work as engineer in the Prouty factory building.

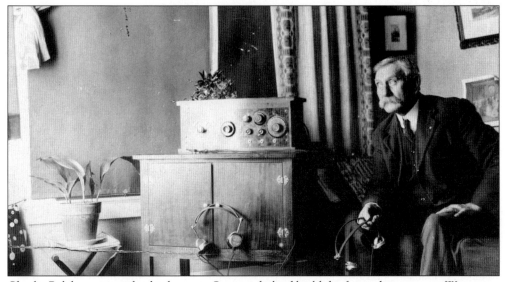

Charlie Belcher, pictured at his home in Spencer, helped build the first radio station in Worcester.

Dr. Charles Barton, a dentist by profession, was also a town moderator for 30 years and a state senator for two years. He practiced dentistry for 47 years, retiring in 1917 when his son took over the business. He died on August 30, 1928.

In 1910, Charles N. Prouty challenged Eugene Browning to a foot race from Spencer to Worcester. It was a friendly wager brought about by the fact that Prouty carried a walking stick, a habit that Browning attributed to old age. The race was held on June 8, 1910, with the wager being refreshments bought by the loser. Two hours and twenty-eight minutes later, Prouty arrived first at Franklin Street. Browning showed up seven minutes later and had to buy the beverage of choice. They each drank a glass of milk.

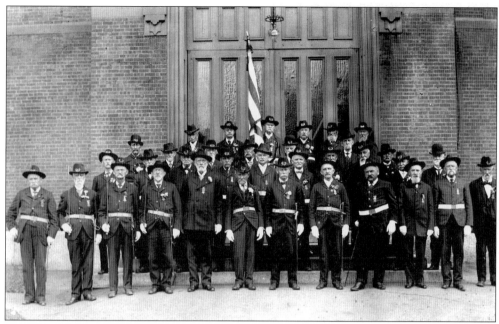

An October 1, 1908 photograph shows members of Frazer A. Stearns Post No. 37 GAR. Seen here are, from left to right, the following: (front row) George L. Smith, A.N. Lamb, ? Dennis, Elmer J. Bean, John W. Hersey, Charles A Bemis, Wesley Smith, Marshall Jarvis Jones, Joseph Hazlehurst, Albert W. Morse, and Reubin Walker; (middle row) Daniel Durning, John W. Bartlett, D.F. Monroe, Anson I. Collier, A.M. Tourtelotte, B.F. Hamilton, Frank Rhieu, Charles H. Allen, Patrick Hennsey, C.D. Worthington, Edwin A. Rice, Hiram Chase, ? Bouley, G.F. Hutchins, and George P. Ladd; (back row) C.A. Bacon, ? Proctor, James Holmes, C.W. Estes, W.C. Wiswell, John M. Hill.

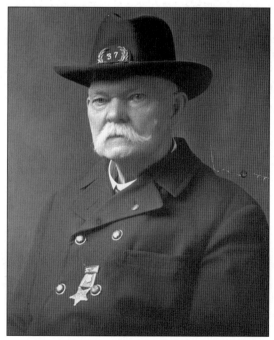

James Holmes was a member of Frazer Stearns Post No. 37 GAR.

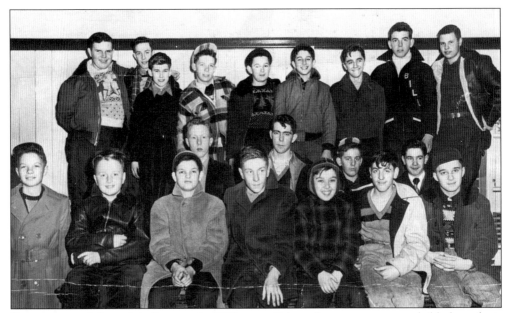

If a paper was delivered in Spencer in 1950, one of these fine young men probably brought it to the door in all kinds of weather.

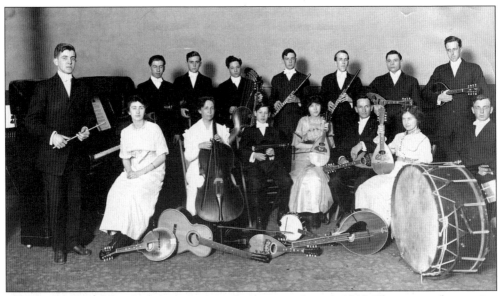

The Spencer Mandolin Orchestra gave a performance on June 4, 1918. There were also moving pictures in connection with the music.

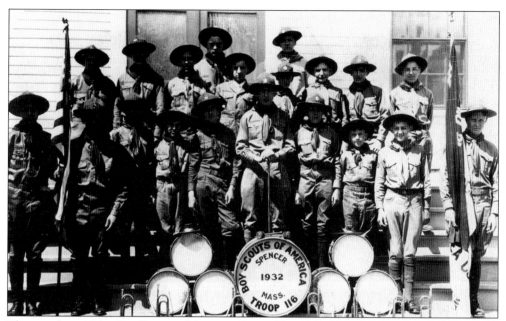

The members of the Boy Scouts of America Troop No. 116 of Spencer stand proudly in 1932.

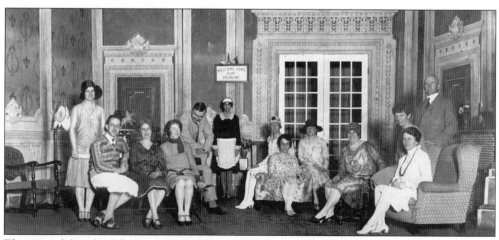

The cast of the play *The Famous Mrs. Fair* gather for this 1928 photograph.

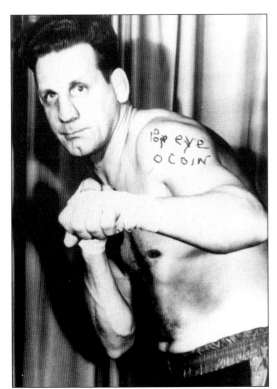

There weren't many places in town one could go without seeing an autographed picture of "Popeye" O'Coin. A well-known pugilist, he was well liked by all but his opponents.

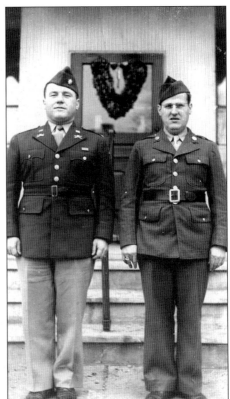

Maj. Nate Quinn and his brother, S.Sgt. Phil Quinn were ready to serve their country.

Ralph Corcoran, a reporter for the *Worcester Telegram and Gazette*, probably captured more pictures of Spencer life than any other individual.

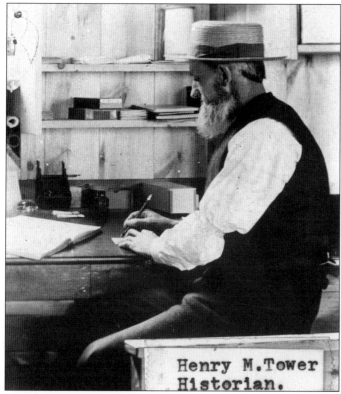

Henry M. Tower
Historian.

Henry M. Tower was a prolific writer who captured the history of Spencer in a series of books.

Ernest L. Roberts moved to town in 1922 and fell in love with it. He began collecting historical items and pictures while in high school and eventually amassed a large collection of photographs. Known to his friends as Ernie, he owned the newsroom in the Sugden Block for more than 20 years. This picture was taken in 1914. He died in June 1999.

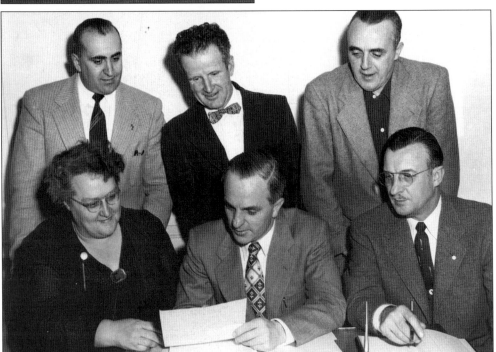

Seen here is the 1953 Bicentennial Committee. Members pictured here are, from left to right, the following: (front row) M. Elizabeth Morse, Roland Aucoin (chairman), and Eugene Grenier; (back row) Emery Delongchamp, Howard Hurley, and Raymond Parks.

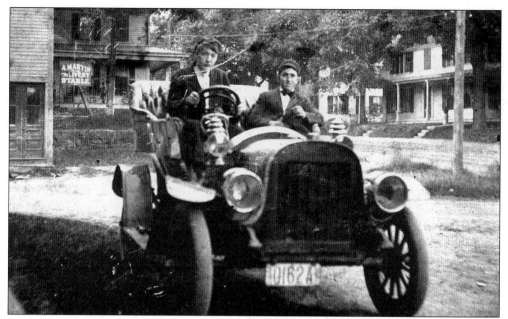

Parked in front of A. Martin's Livery Stable are Charlie Letendre, driver, and Noie Letendre, a passenger along for the ride.

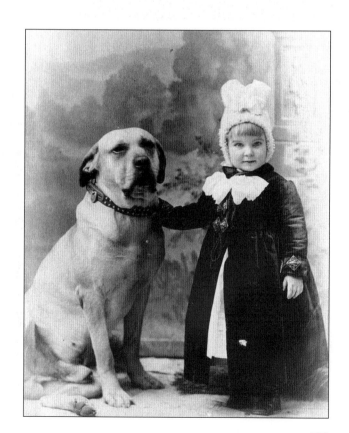

Geraldine Prouty and her faithful dog, Trusty, resided at 27 High Street.

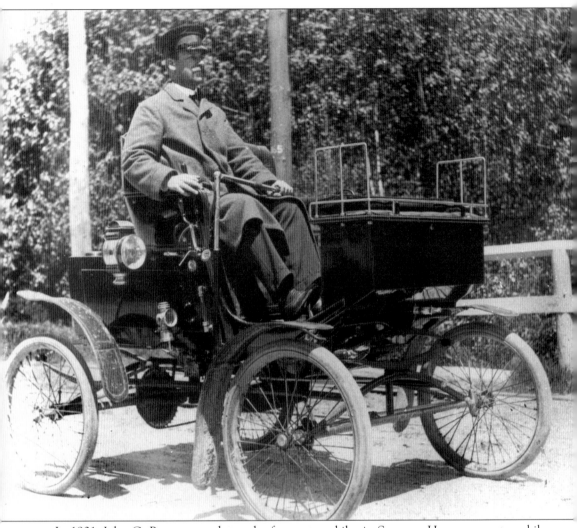

In 1901, John G. Prouty owned one the four automobiles in Spencer. He was an automobile enthusiast and bought many cars over a short span of years. He built the first structure to specifically shelter his vehicle. The garage was behind his home at 25 High Street. Prouty died at the age of 58 in 1923.